EDEN: A GARDEN of BIBLE VERSES
40 GRAYSCALE IMAGES

by *janet w long*

THIS BOOK BELONGS TO:

START _____

FINISH _____

AMAZON AUTHOR PAGE:

https://www.amazon.com/author/janetlong

ETSY VINTAGE SHOP

"Go green! Buy vintage!"
https://www.etsy.com/il-en/shop/AdoptionsLtd

ETSY "JLA" SHOP

https://www.etsy.com/shop/JanetLongArts

[Photography & Watercolor prints, Hand Knits]

This book was developed by Janet W. Long in February 2017.

The images are photographs I have taken in my own yard & garden.

I've included some images from the public domain.

[Contact me if you find any images that are NOT in the public domain.]
unrise@hotmail.com

These images may not be replicated in any way without the express, written permission from Janet W. Long.

ISBN-13:978-1535456487 ISBN-10: 1535456485

© Janet Long Arts. All rights reserved.

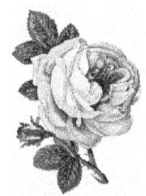 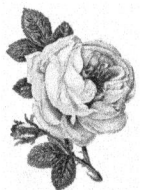 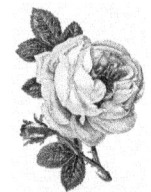

EDEN, A GARDEN of BIBLE VERSES:
Inspirational words & whimsical Quotes
40 GRAYSCALE IMAGES

INTRO...

I've chosen some of my own photography from my own yard & garden for this book. I added a few public domain images for you to turn into home décor if you wish. Several of my images in this book are in the 'film noir' style, deep black & white. When coloring these images, I like to leave the blacks intact & color the lighter areas for a dramatic, eye-catching look.

In grayscale coloring, the shading is already there. *Everyone can be a great artist!* Just apply a layer of color & there's your picture! I have intentionally put some lighter grayscale images in this & my other books, so you can have a bit more artistic 'freedom' to add your ideas.

There are blank pages at the back for your notes & coloring tool testing. The publisher has only one paper choice. I feel that it's a bit thin. But, that can be a strength when you are able to get a beautiful picture without having to do many layers or use too much pressure.

Discover how your various pencils or crayons interact to create the colors you love. You don't have to buy all the coloring tools & colors out there. You'll see that even if you have only ONE red pencil, you can create many shades of red by using a blue, orange, purple underlay/overlay. Use as many layers as you wish. *You're the colorist!*

If you choose gel pens, felt tips, or other more 'liquid' mediums, please put a piece of cardstock or other paper behind your color work to catch any possible bleed through. You may want to cut out the pages to get a more open space to color. Go ahead, frame your work! Put it on your walls or give as a gift. It's ART!!

 # ENJOY!

THANK YOU, ANGELIA MILLER FOR COLORING THE LAMB

FIND ME

AMAZON AUTHOR PAGE: http://amzn.to/2g7qeAZ
ETSY VINTAGE SHOP: https://www.etsy.com/shop/AdoptionsLtd
ETSY SHOP, "JLA" https://www.janetlongarts/shop/Etsy.com

ETSY "JLA" RETAIL SHOP ON FACEBOOK:
https://www.facebook.com/Janet-Long-Arts-192517394097105/
ETSY VINTAGE RETAIL SHOP on FACEBOOK: http://bit.ly/2iS45YC
TWITTER: https://twitter.com/jan43q
PINTEREST: http://pinterest.com/janetlongarts/
LINKEDIN: ttp://www.linkedin.com/profile/view?...

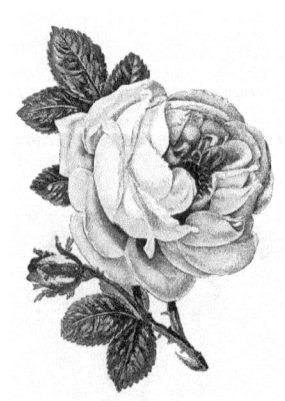

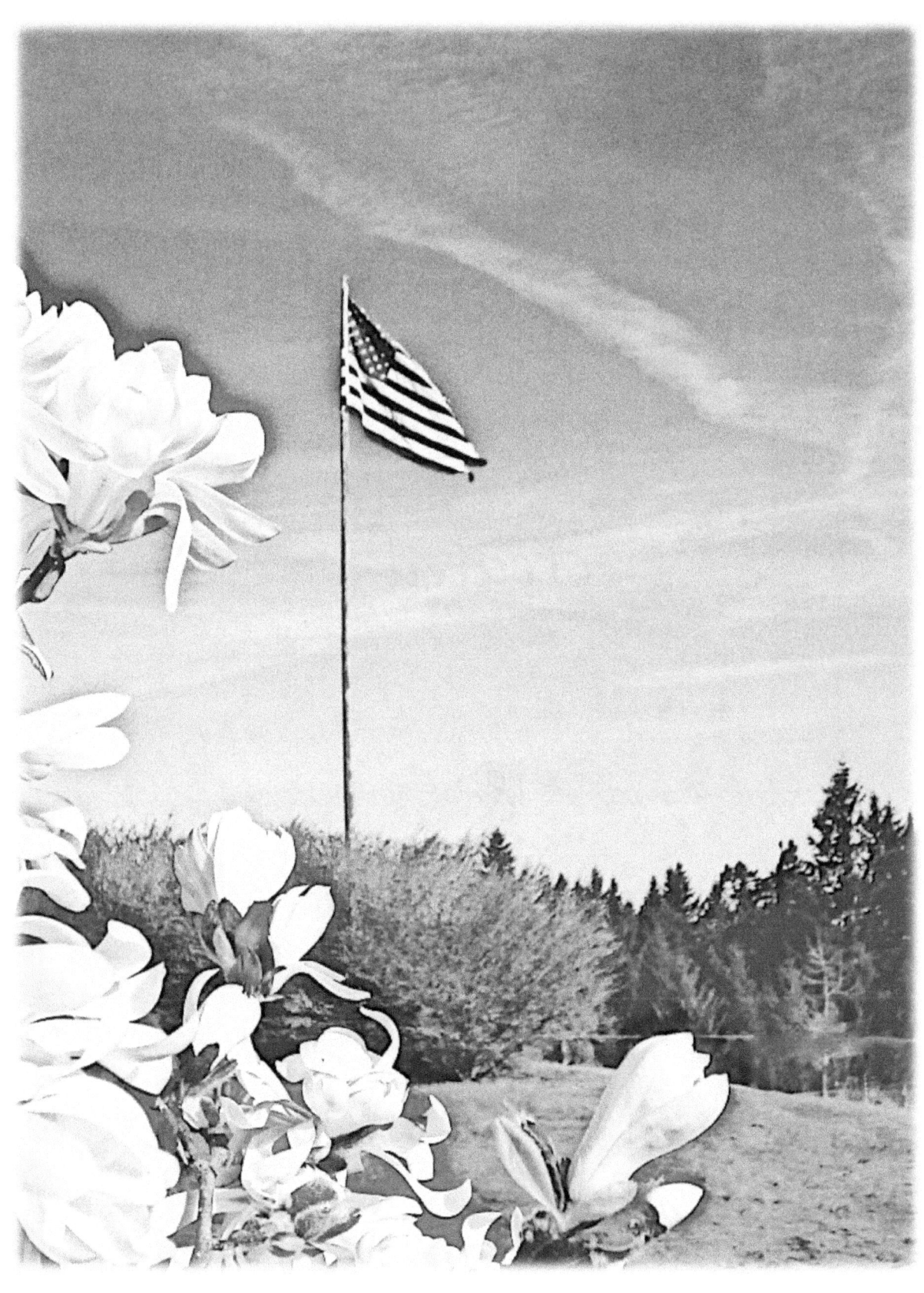

OUR OWN FLAG VIEWED THROUGH CHERRY BLOSSOMS

In the beginning,
GOD
created
HEAVEN
&
EARTH

Genesis 1:1

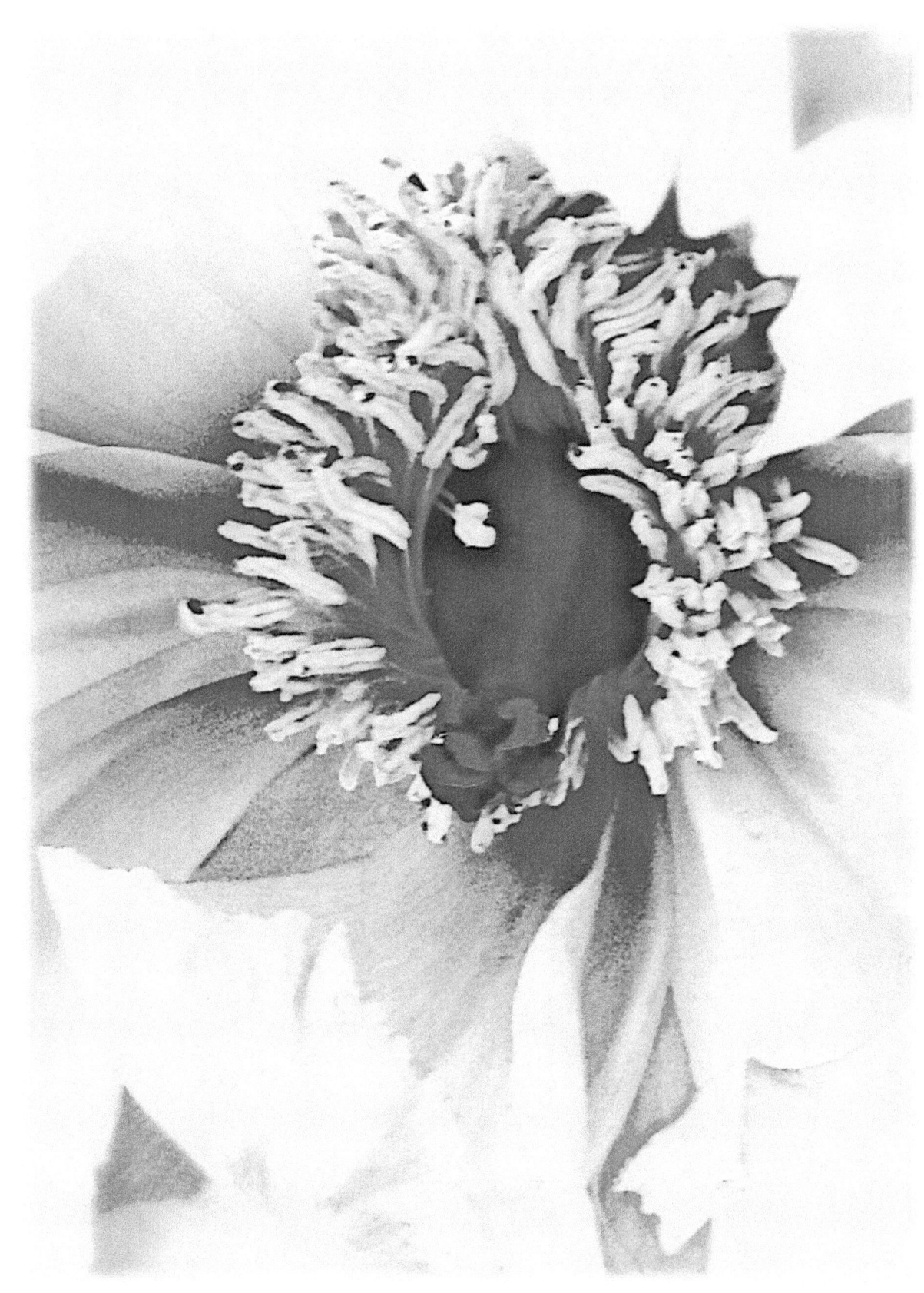

TREE PEONY

The LORD is my SHEPHERD! Wherever I am HE is with ME! Psalm 23

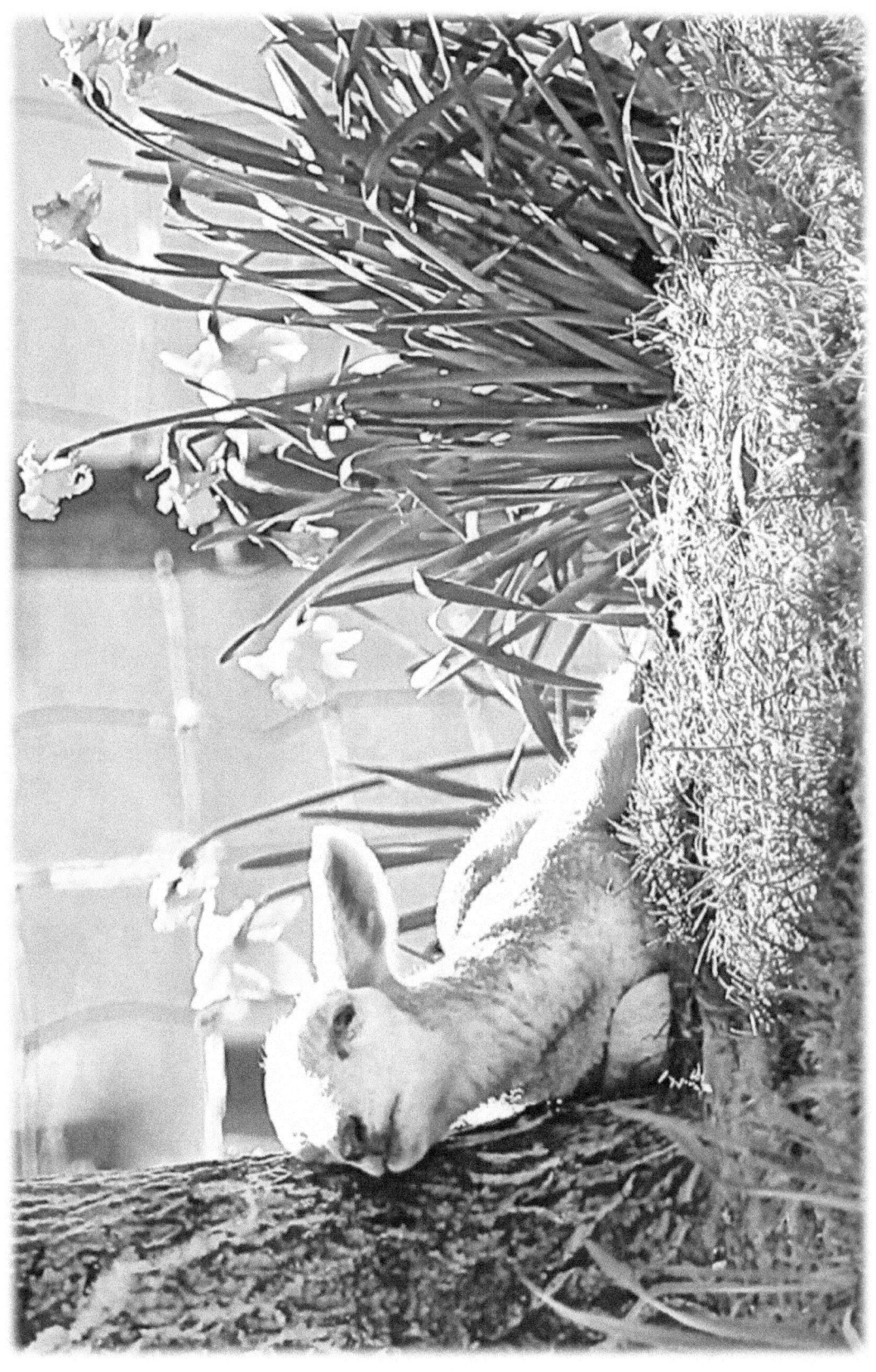

Be still
&
KNOW
that
I am
GOD.

Psalm 46:10

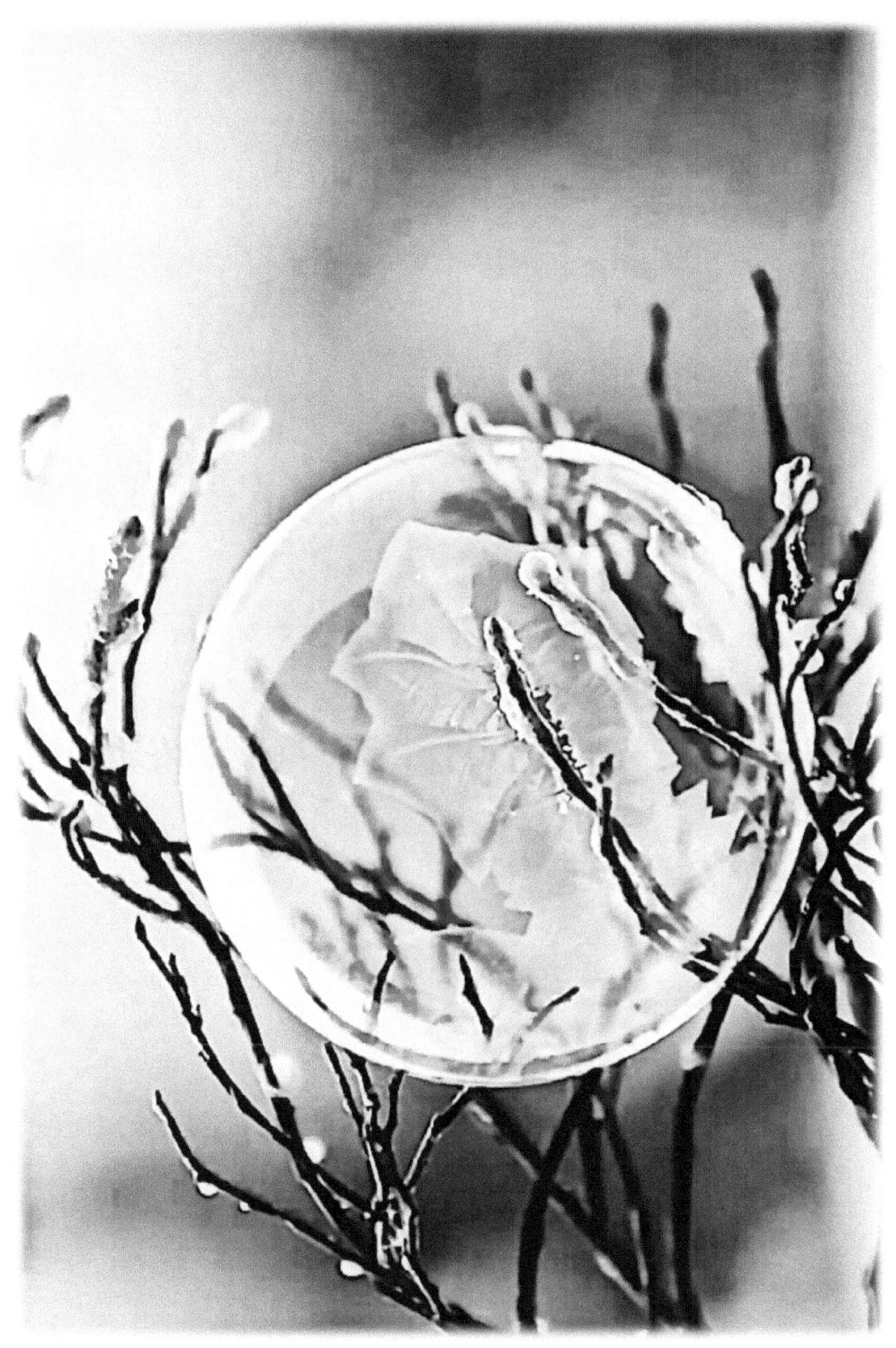

FROSTED BUBBLE

G‌REAT *is* G‌OD'S L‌OVE *toward us, & the* F‌AITHFULNESS *of the* L‌ORD *endures forever. Praise the* L‌ORD*!*
Psalm 117

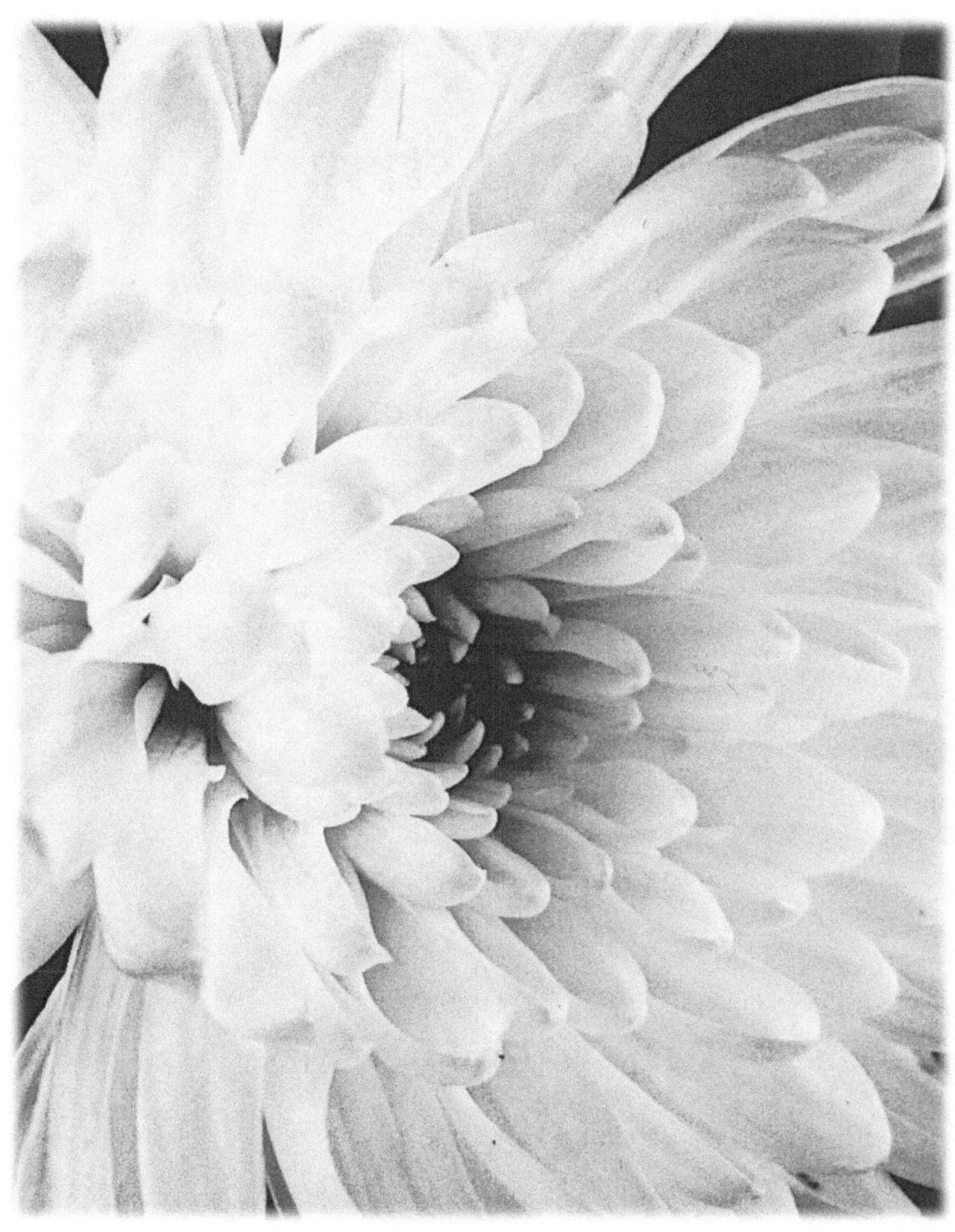

MUM "Limelight & lilac"

Always strive to do what is GOOD for each other & everyone else.

1 Thessalonians 5:15

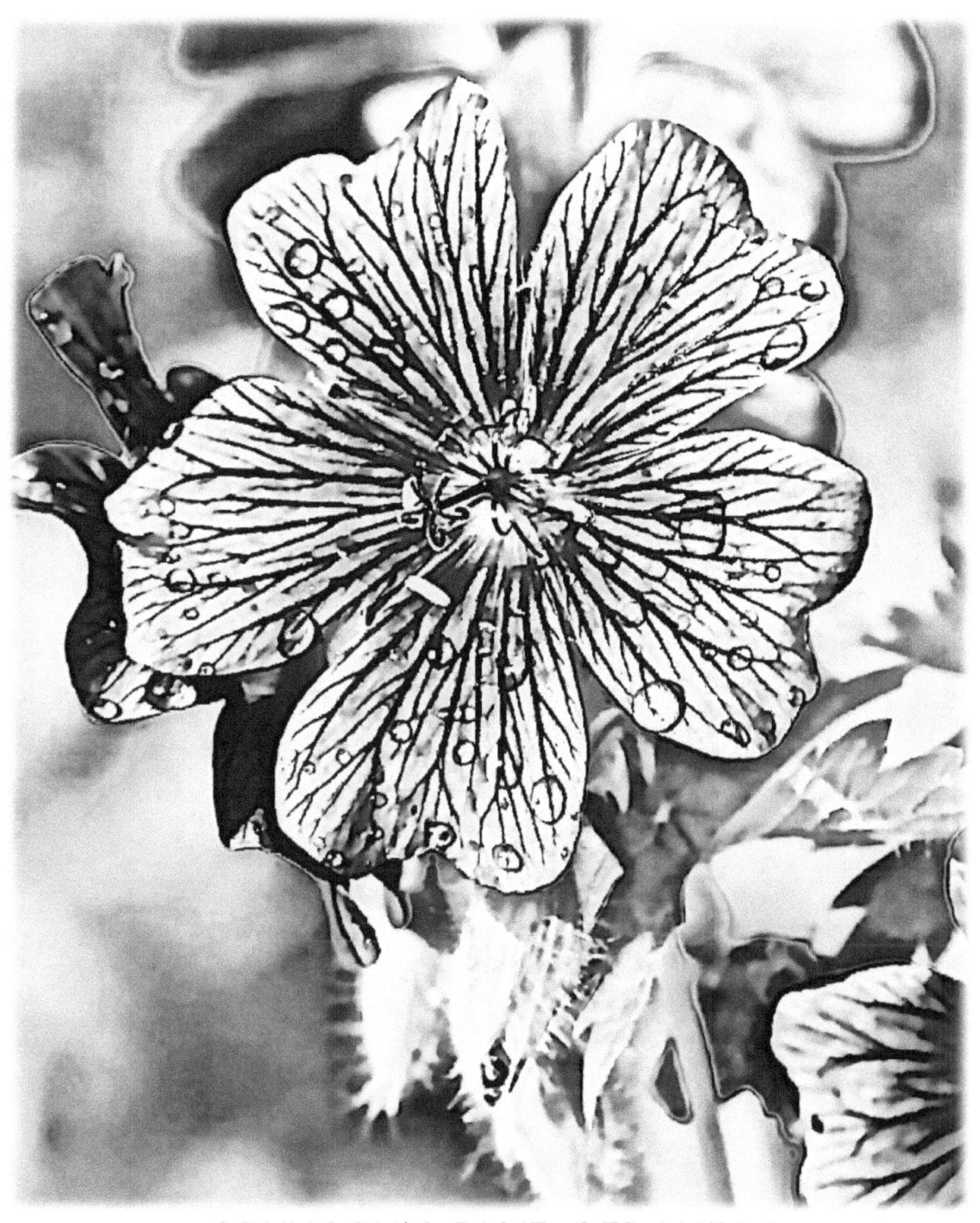

JOHNSON'S BLUE GERANIUM

Wait for the Lord!
Be STRONG!
Take HEART &
just WAIT...

Psalm 27:14

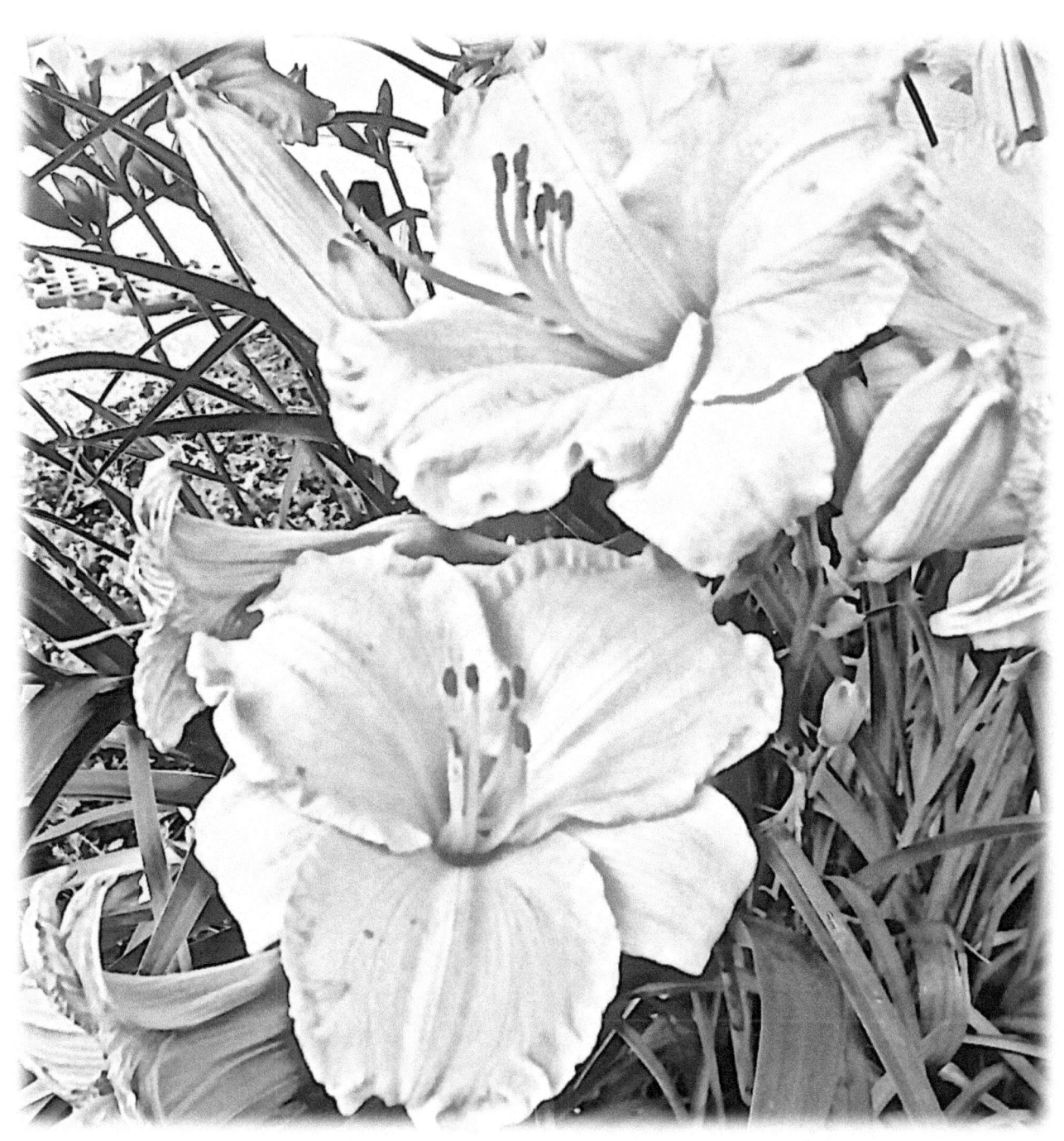

YELLOW DAY LILIES

Give ALL your ANXIETY to JESUS because He cares for YOU!

I Peter 5:7

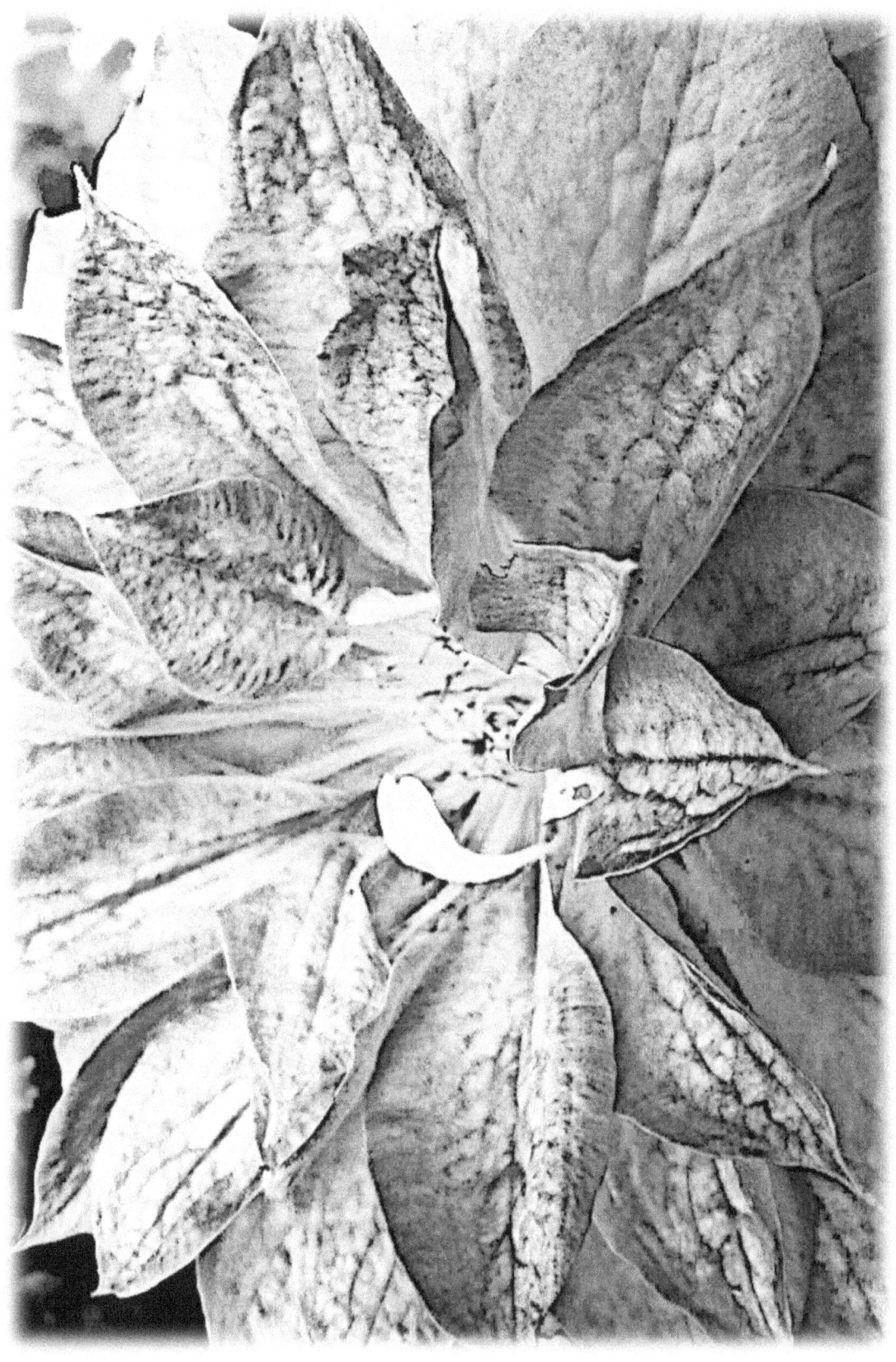

CLEMATIS

Even the sparrow has found a HOME, & the swallow a nest for herself, where she may have her young.

Psalm: 84:3

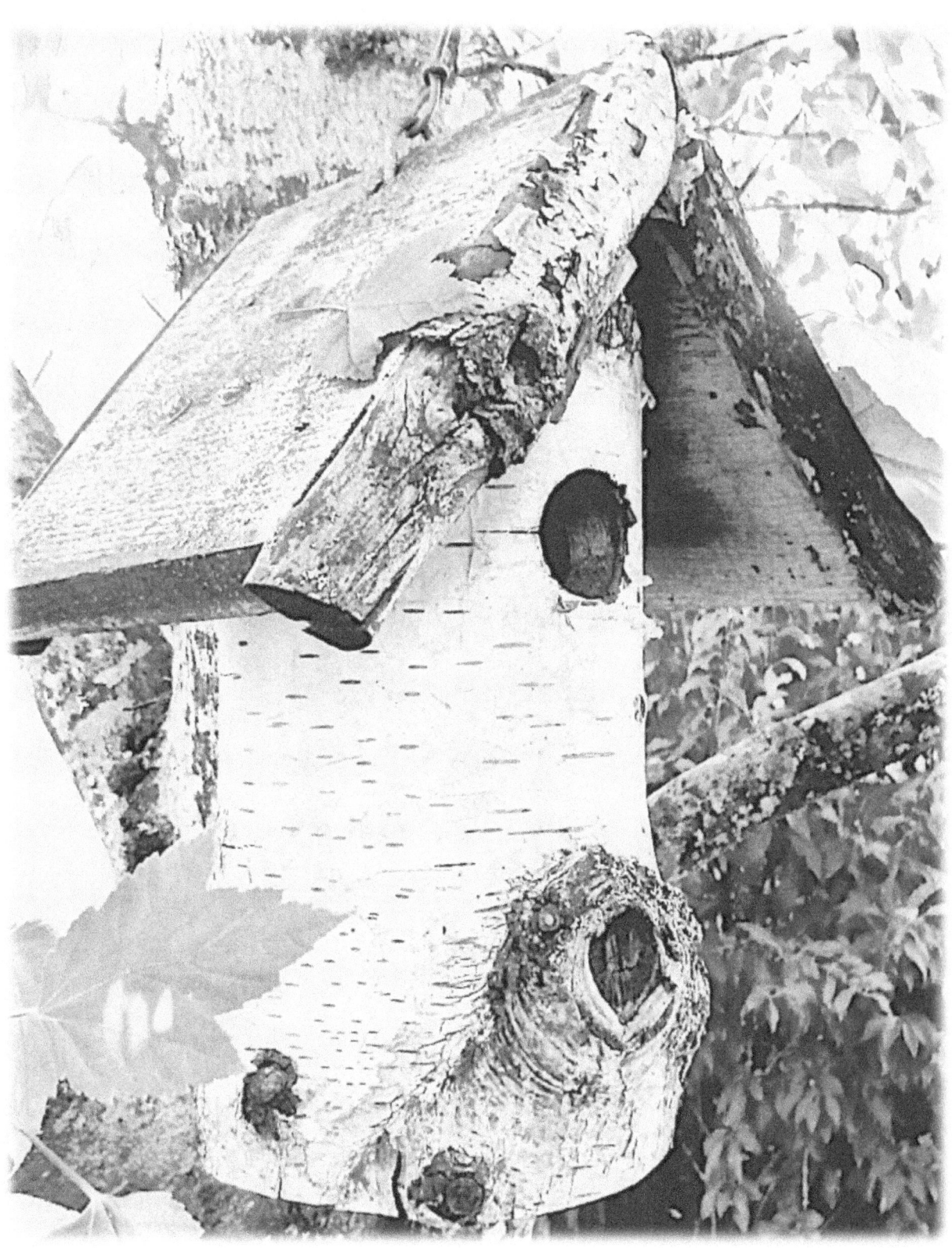

*If you WORRY, you didn't pray.
If you PRAY, don't worry!*

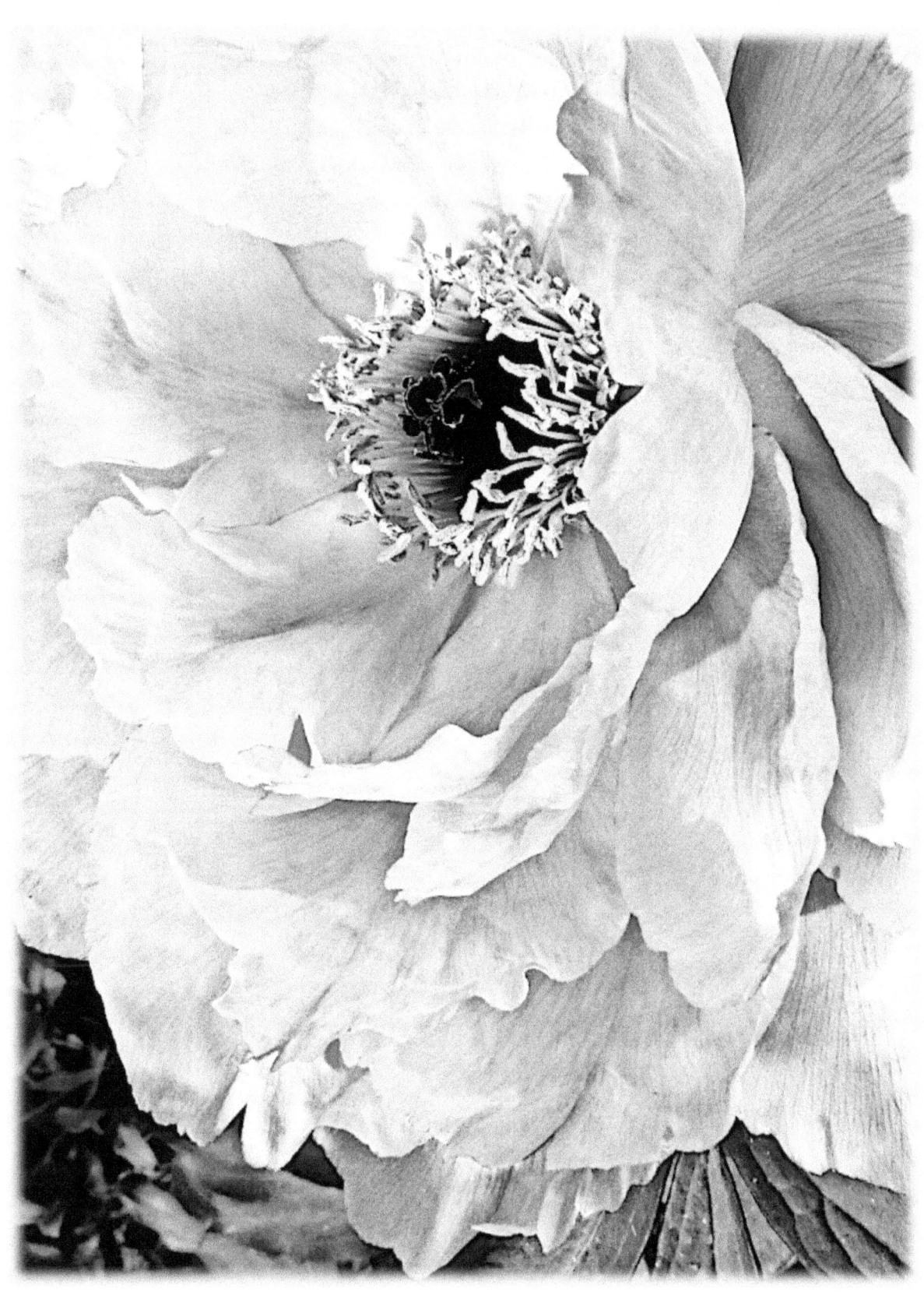

PEONEY

The PEACE of God, which transcends ALL understanding, will guard your hearts & minds in CHRIST JESUS.

Philippians 4:7

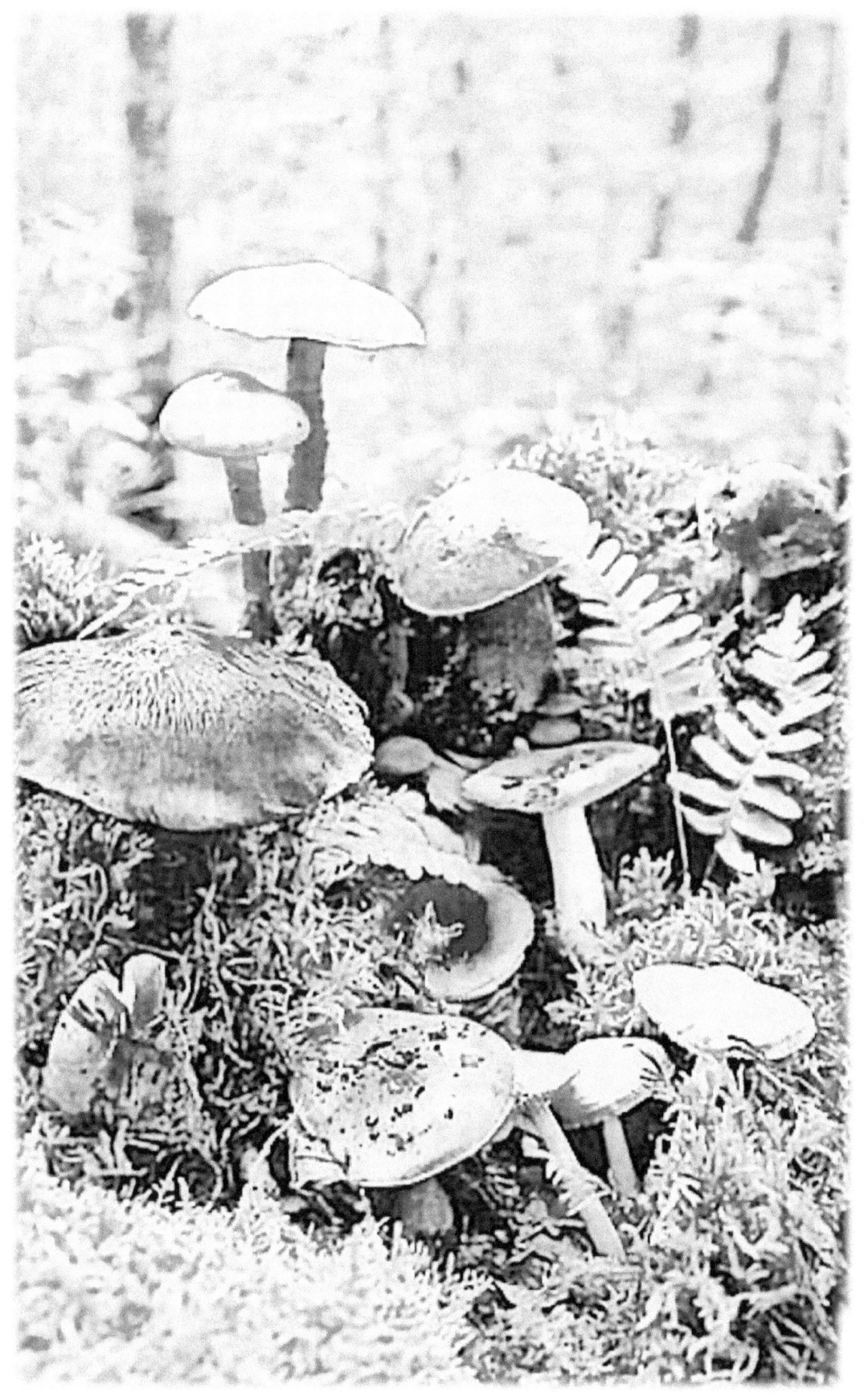

Let the PEACE of CHRIST rule in your HEARTS

Colossians 3:15

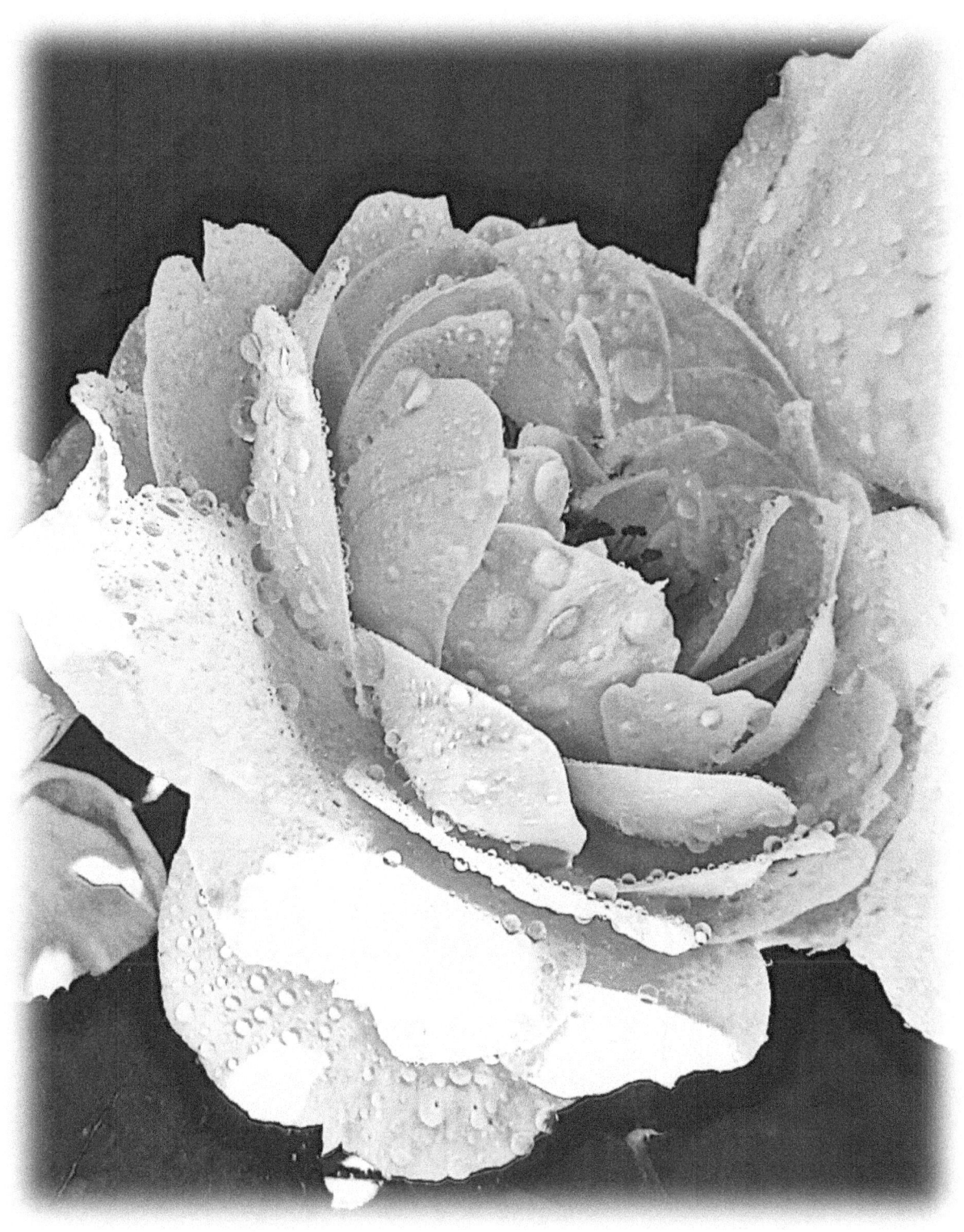

"CUP of DEW" ABRAHAM DARBY ROSE

Show me
unfailing kindness
like the LORD's
kindness
as long as I live.
1 Samuel 20:15

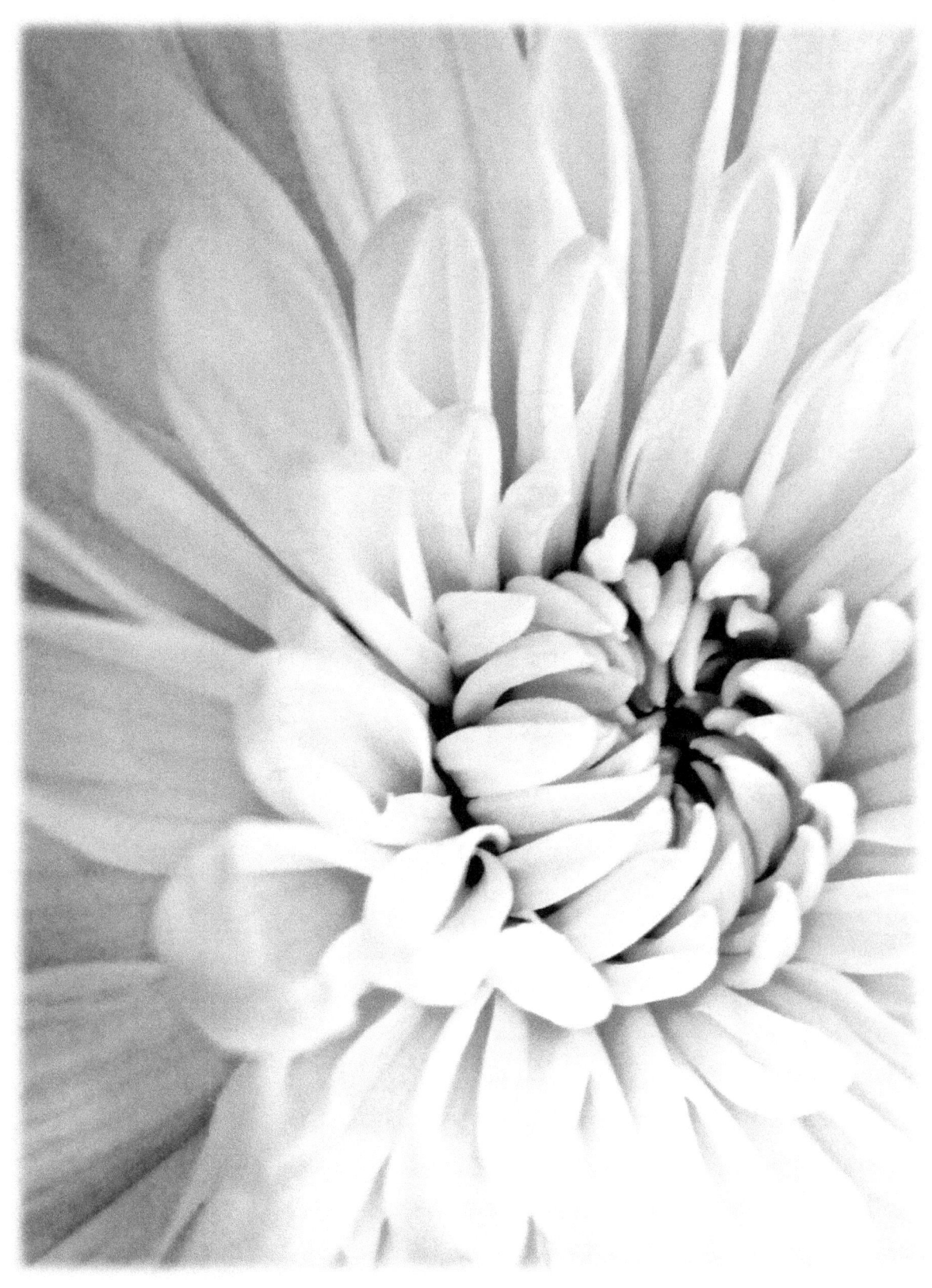

MUM

PEACEMAKERS *who sow in peace reap a harvest of* RIGHTEOUSNESS.

James 3:18

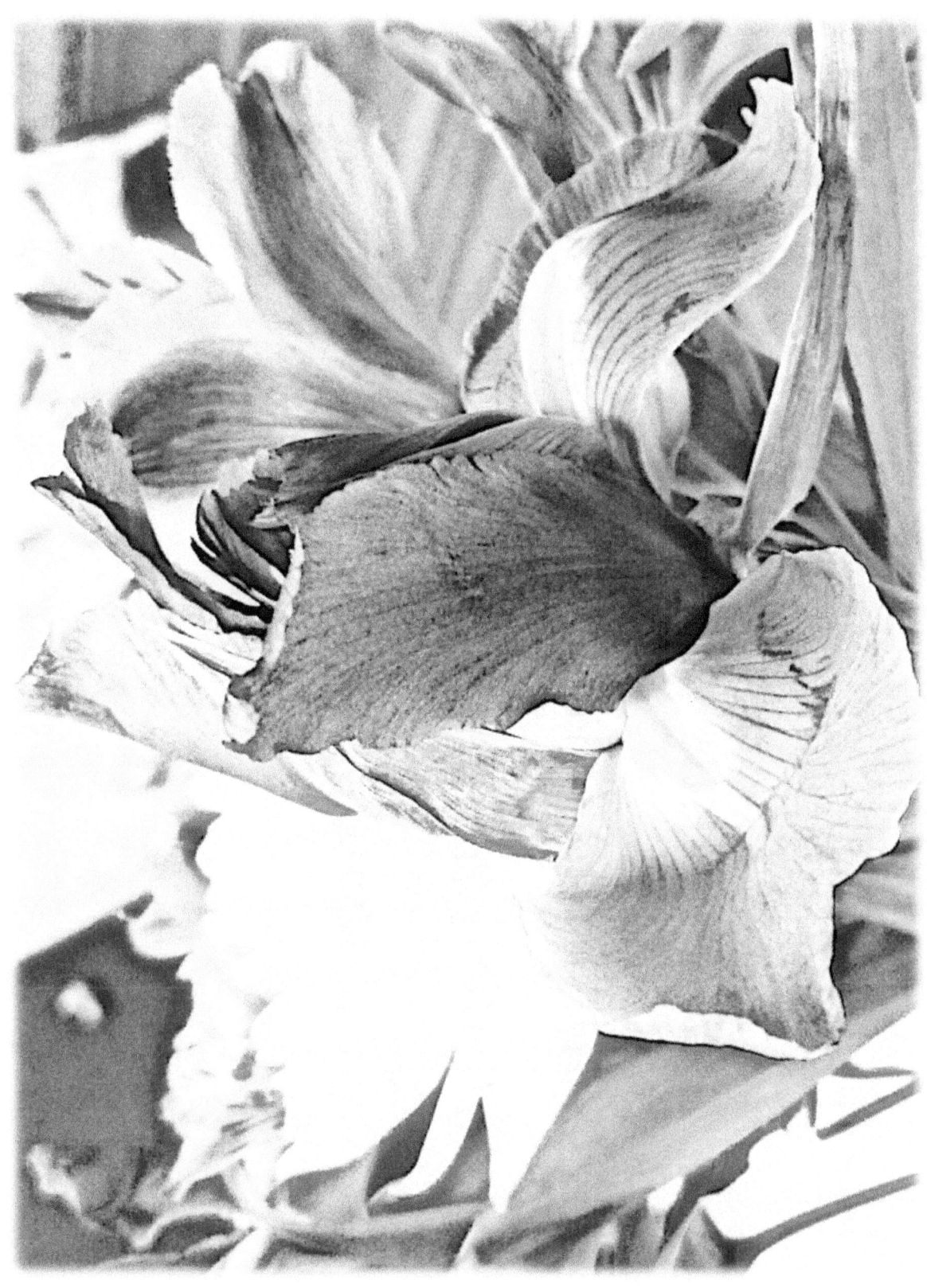

"Though the mountains be shaken and the hills be removed, yet my unfailing love for you will not be shaken nor my covenant of peace be removed," says the LORD.
Isaiah 54:10

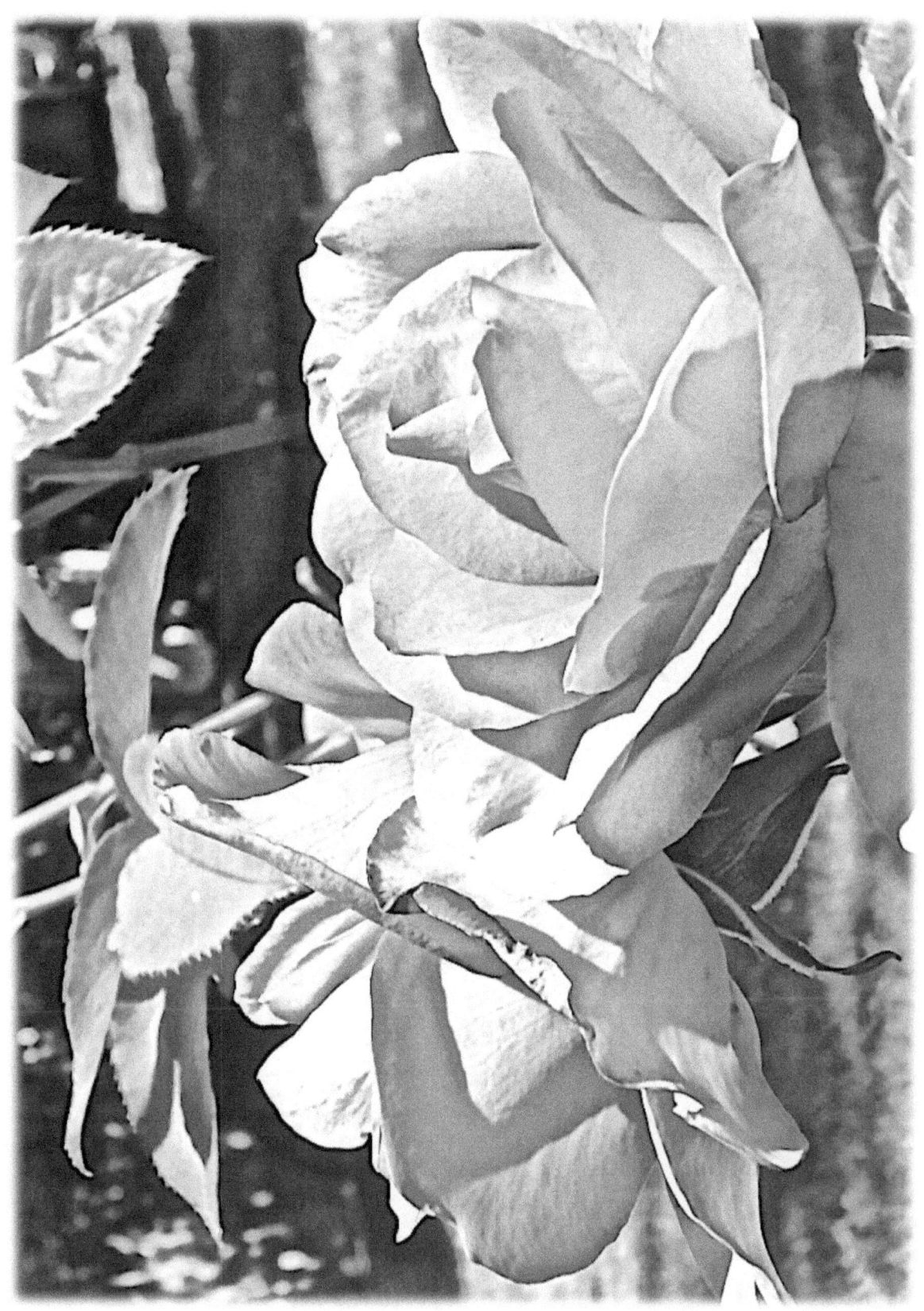

I will send you RAIN in its season

&

the ground will yield its CROPS

&

the threes their FRUIT. Leviticus 26:4

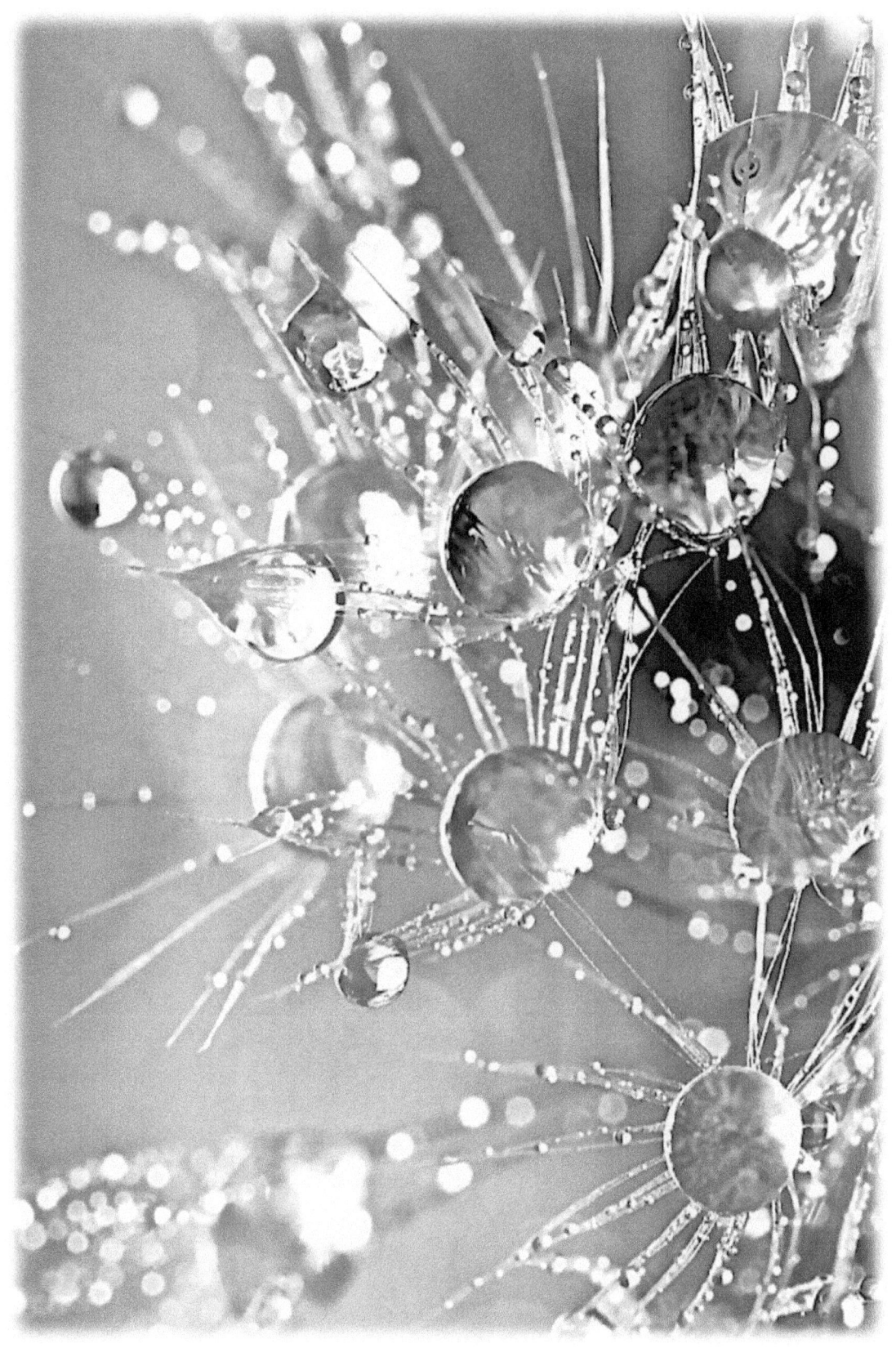

I would encourage you to accept wherever you are on the journey, whether HAPPY or MISERABLE, as the place where GOD will meet you, where He will continue to work in you.

~ L. Crabb

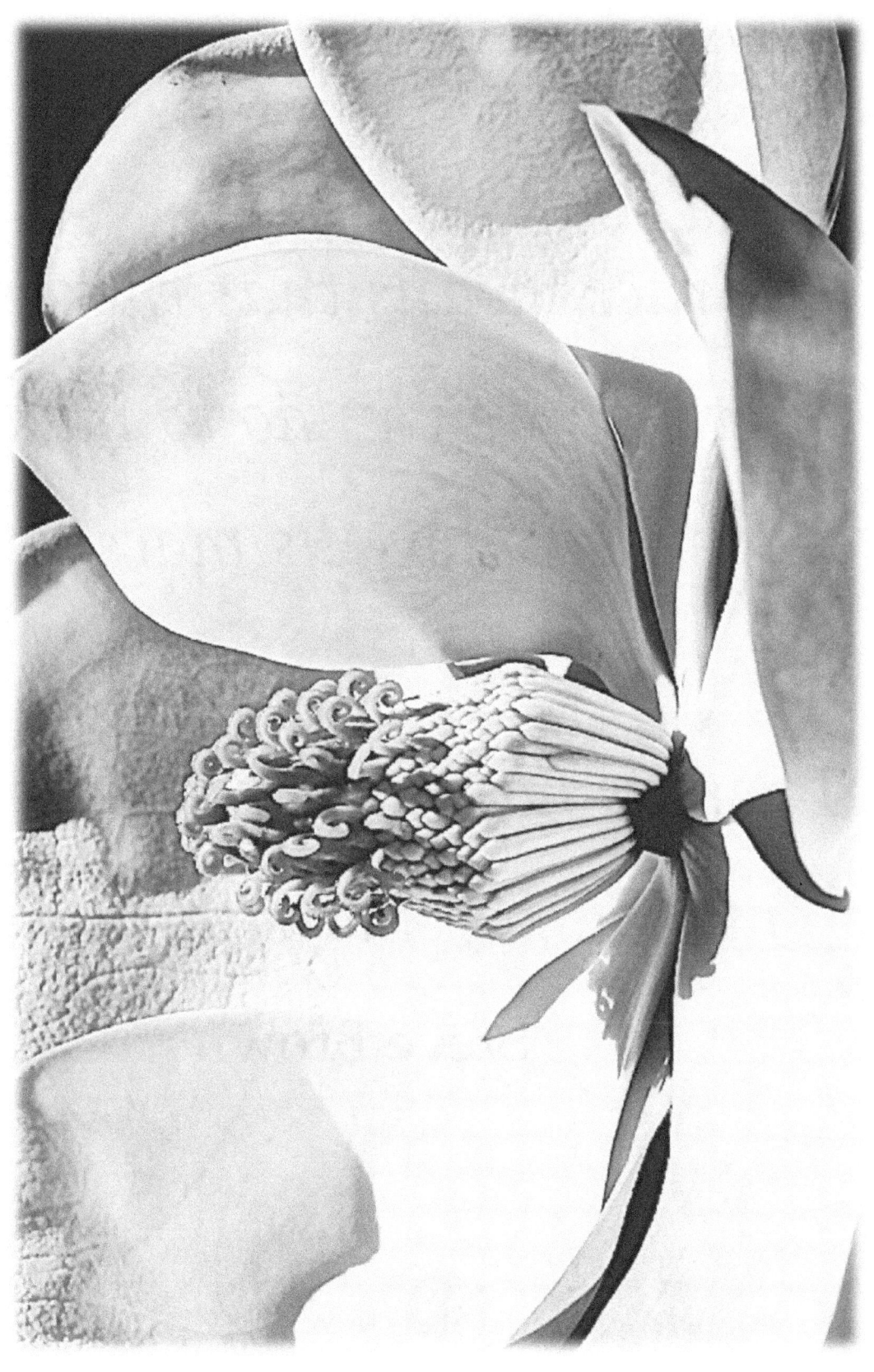

MAGNOLIA BLOSSOM

"Grace means that there's nothing we can do to make GOD love us more.

~ ~ ~

There is nothing we can do to make GOD love us less."

~ Steve Brown

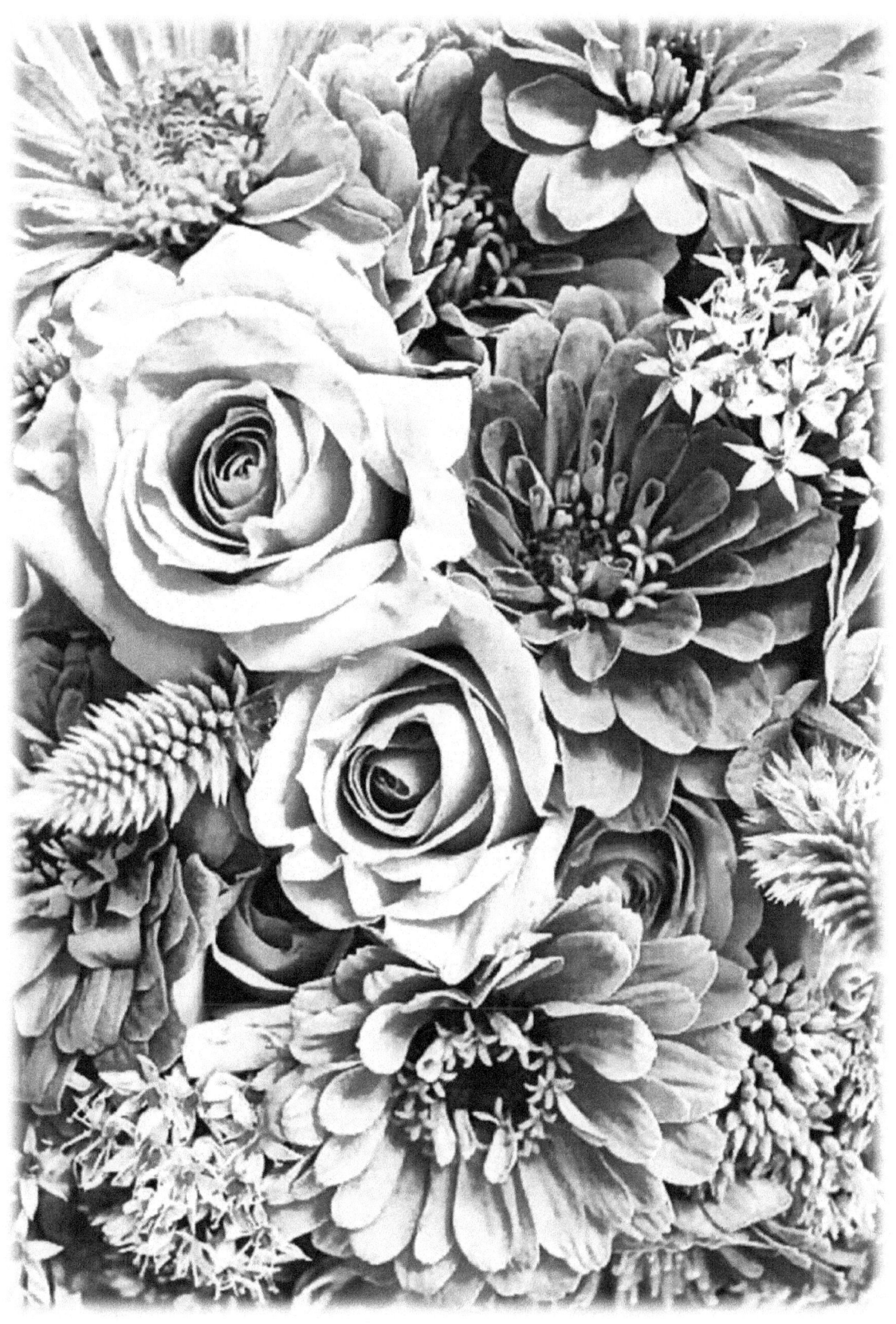

Instead of saying "Let go & let GOD

~ ~ ~

Say, "TRUST GOD & get going!"

~ J. I. Packer ~

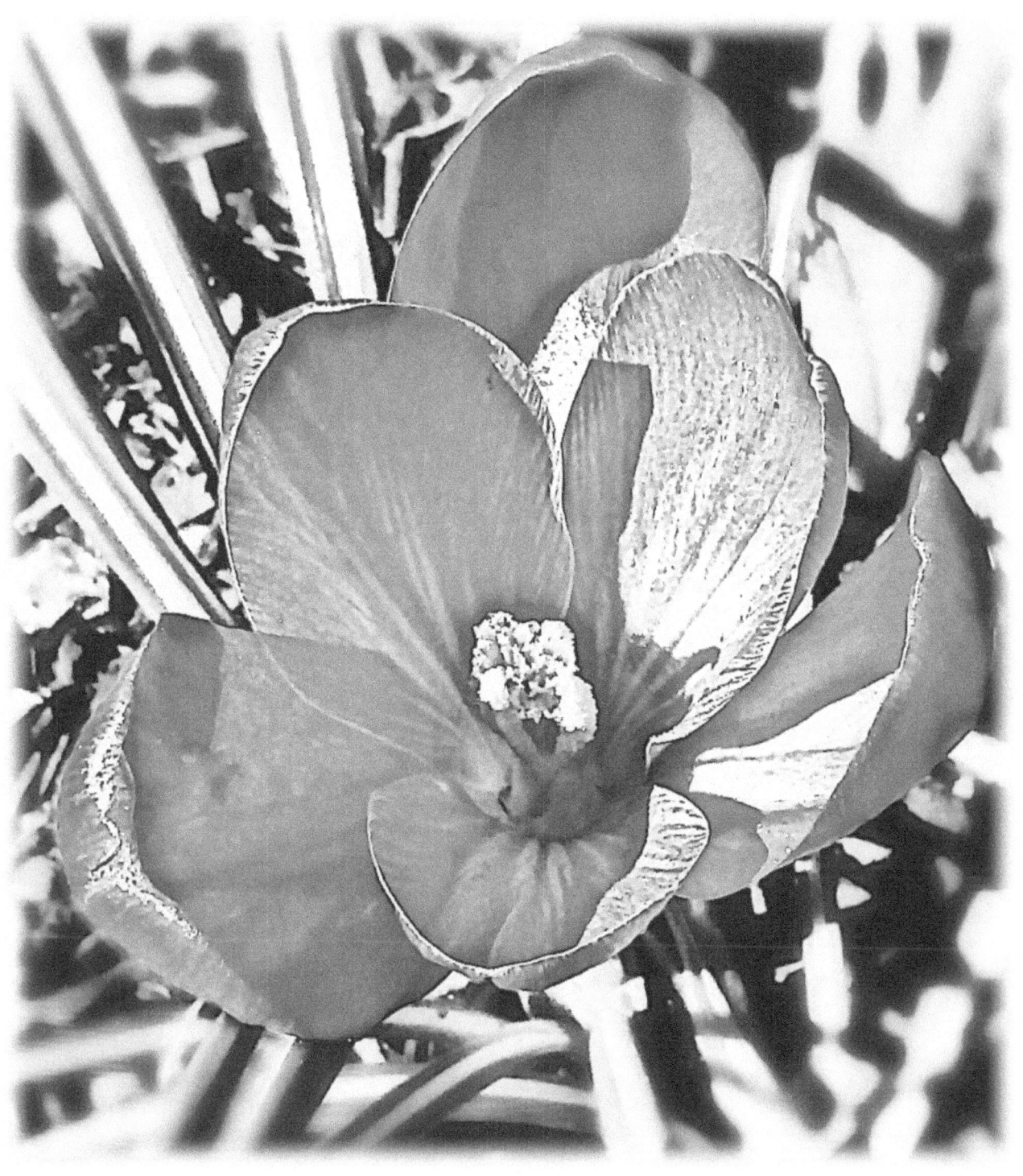

CROCUS

There is no key
to HAPPINESS.

~ ~ ~

The DOOR is
always OPEN.

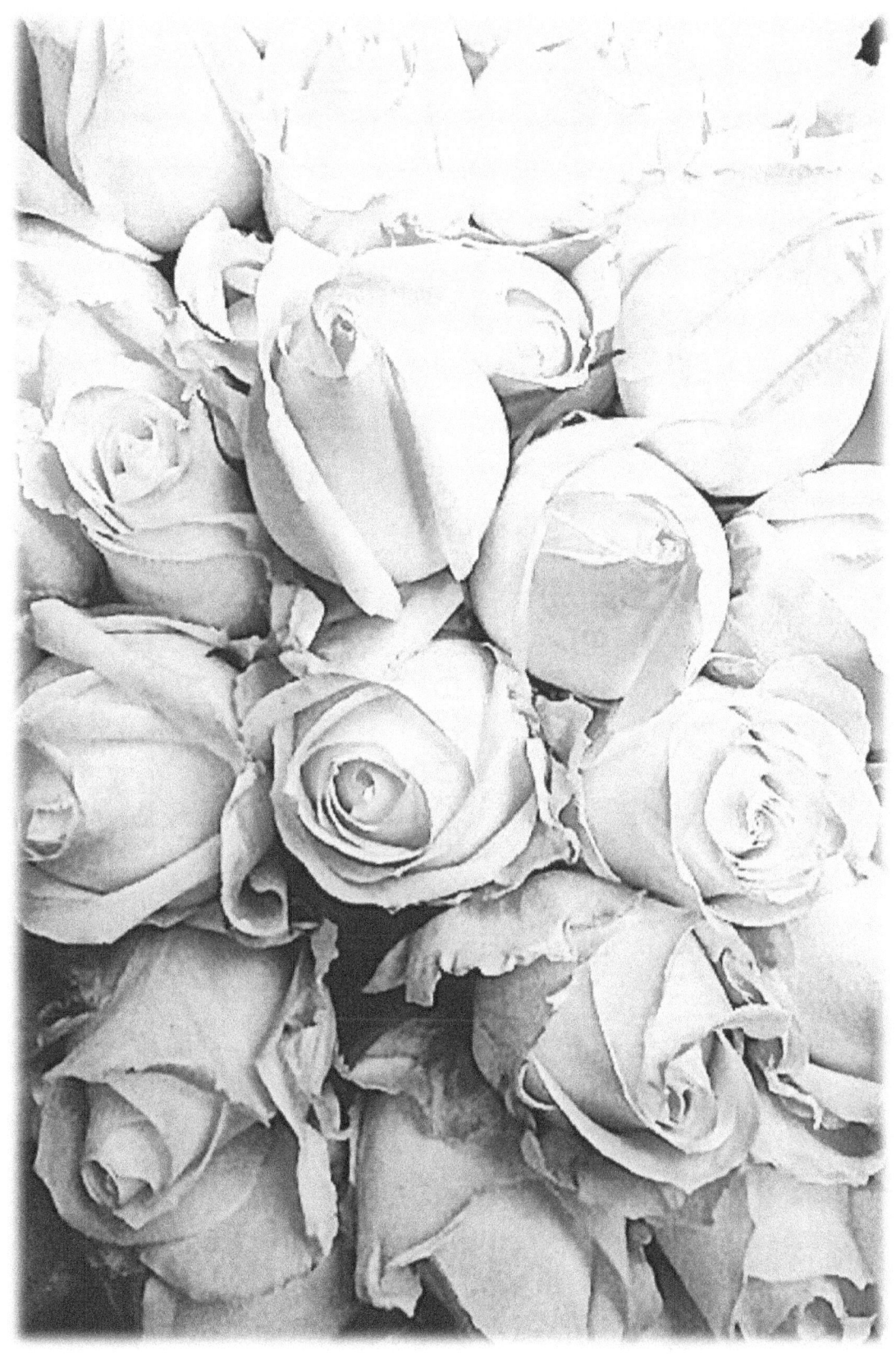

May the LORD turn His face toward you & give you PEACE!

Numbers 6:26

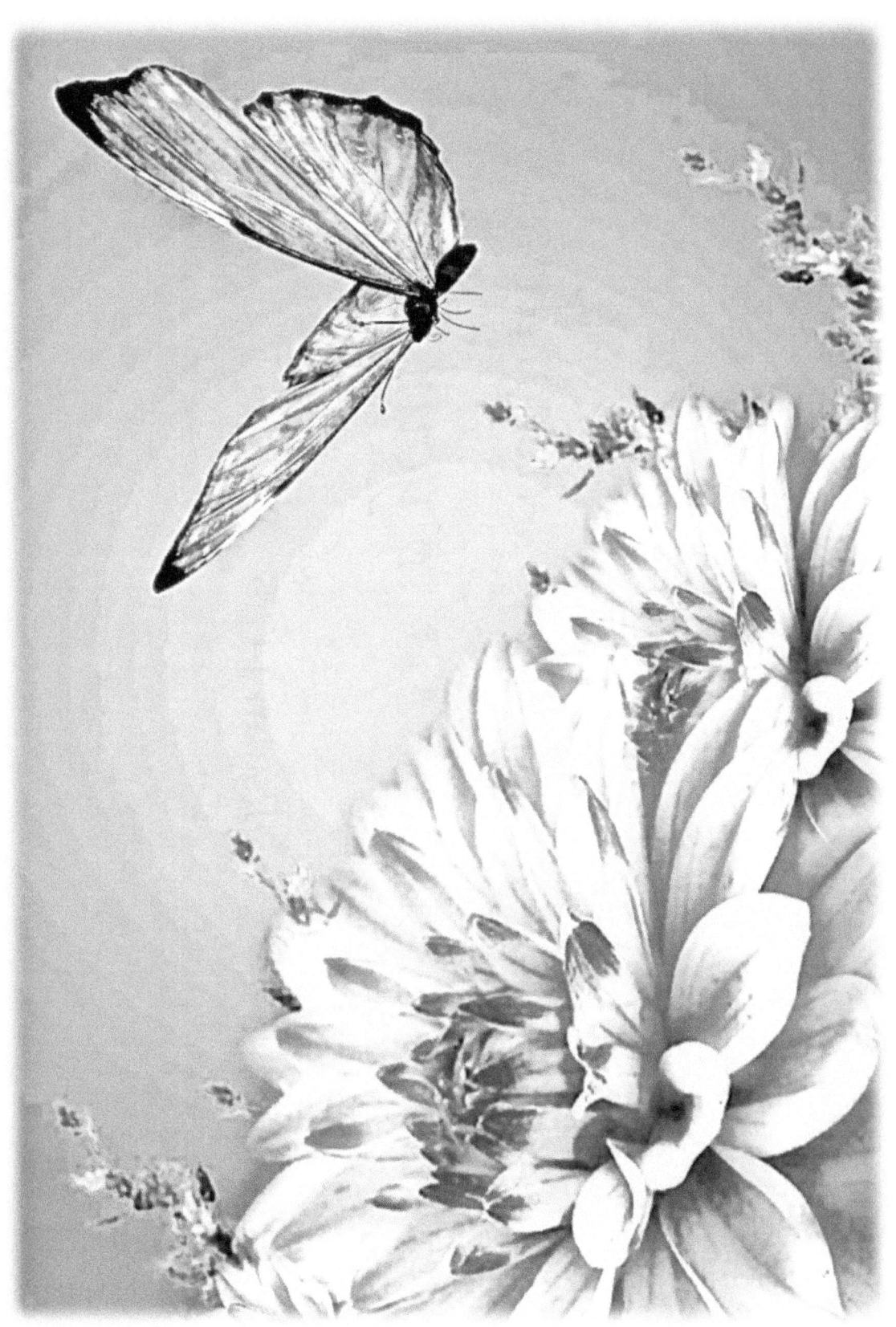

May your unfailing LOVE be my COMFORT, according to your PROMISE to your servant.

Psalm 141:5

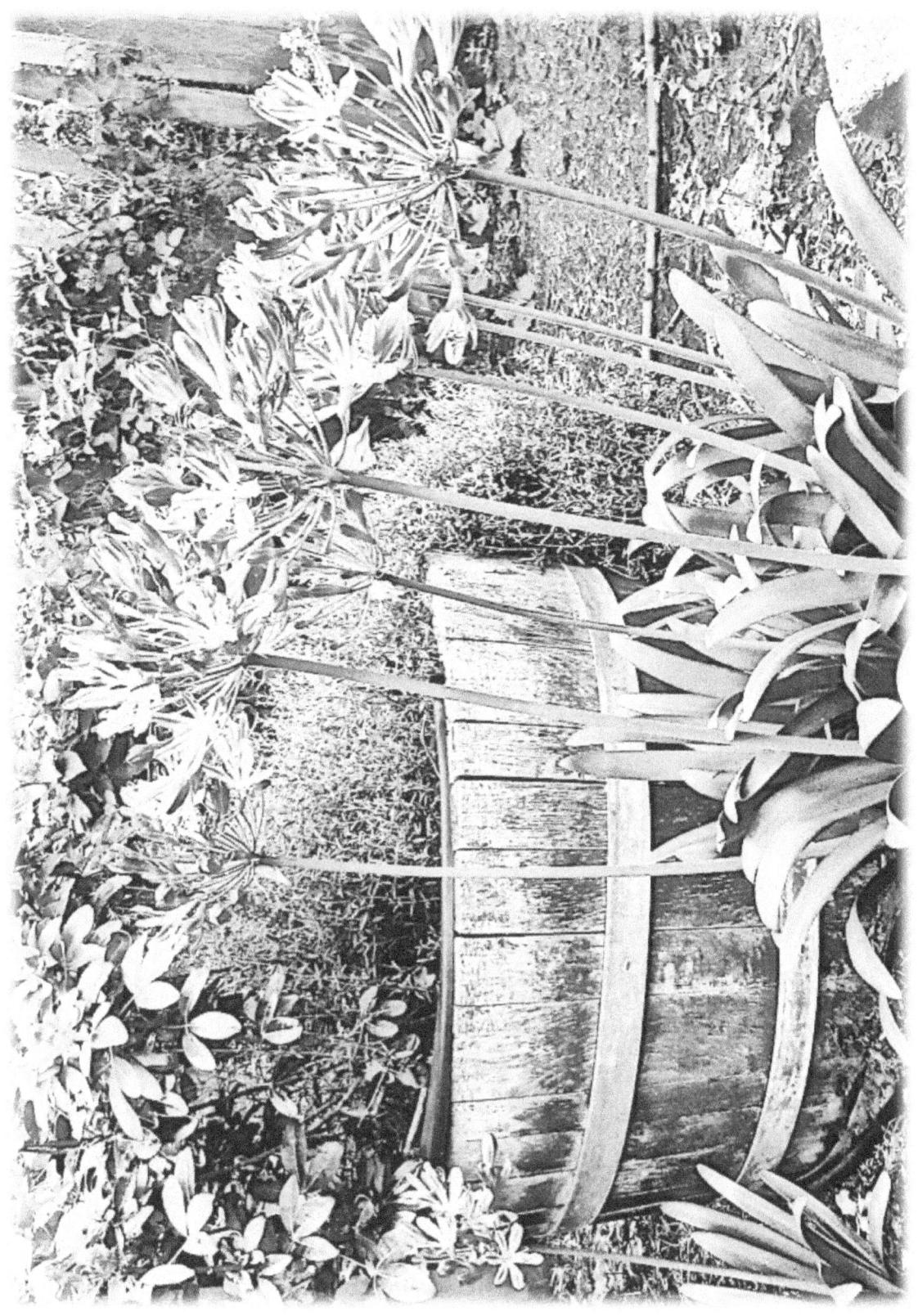

AGAPANTHUS, LILY OF THE NILE

*Do not worry about your life,
what you will eat or drink
or about your body,
what you will wear.
Is not life more than food,
& the body more than clothes?
Look at the birds of the air;
they do not sow or reap
or store away in barns,
and yet your Heavenly
Father feeds them.
Are you not much more
valuable than they?*

Matthew 6:25-34

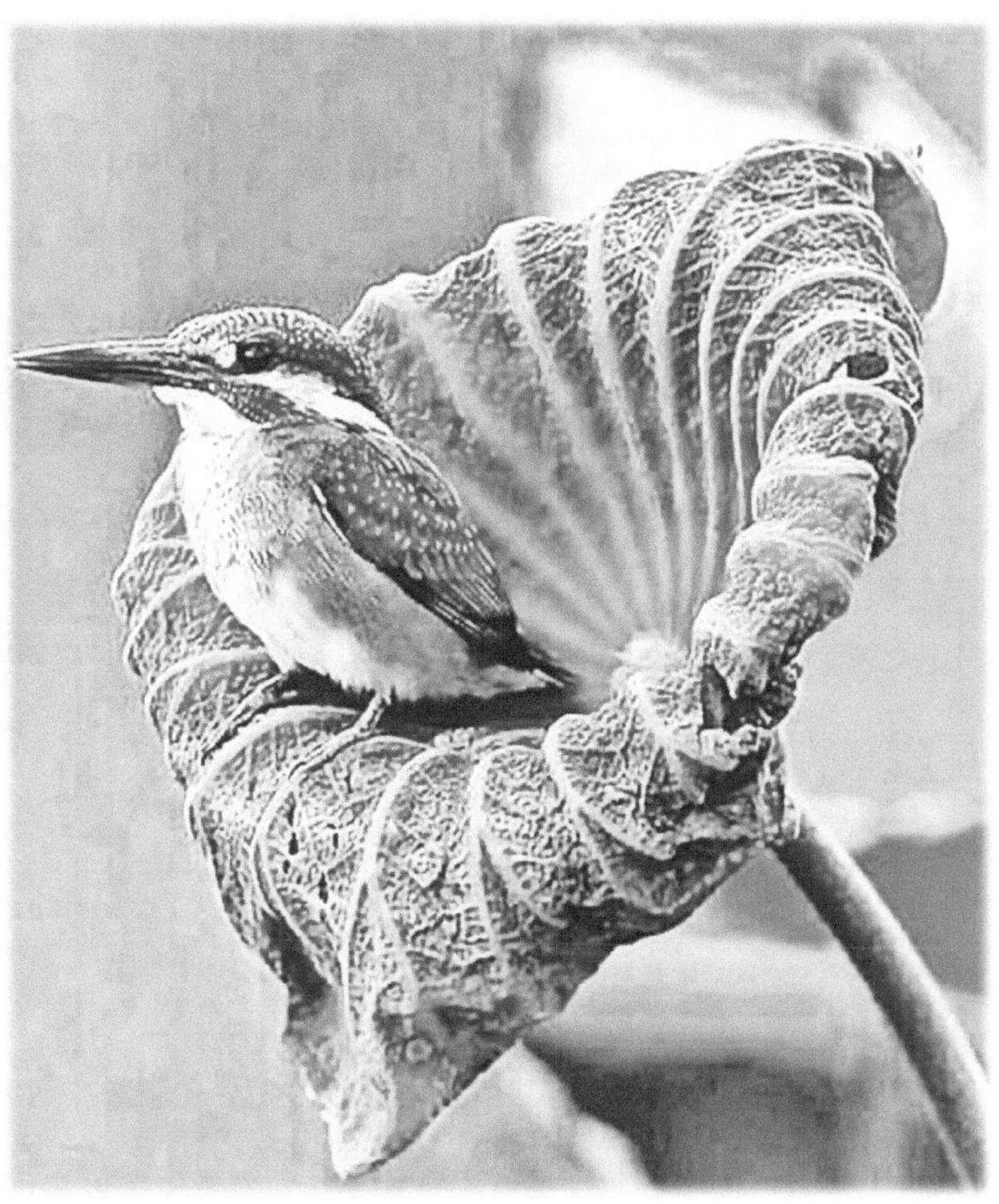

*I am a rose of Sharon,
a lily of the valleys.*

Song of Songs 2:1

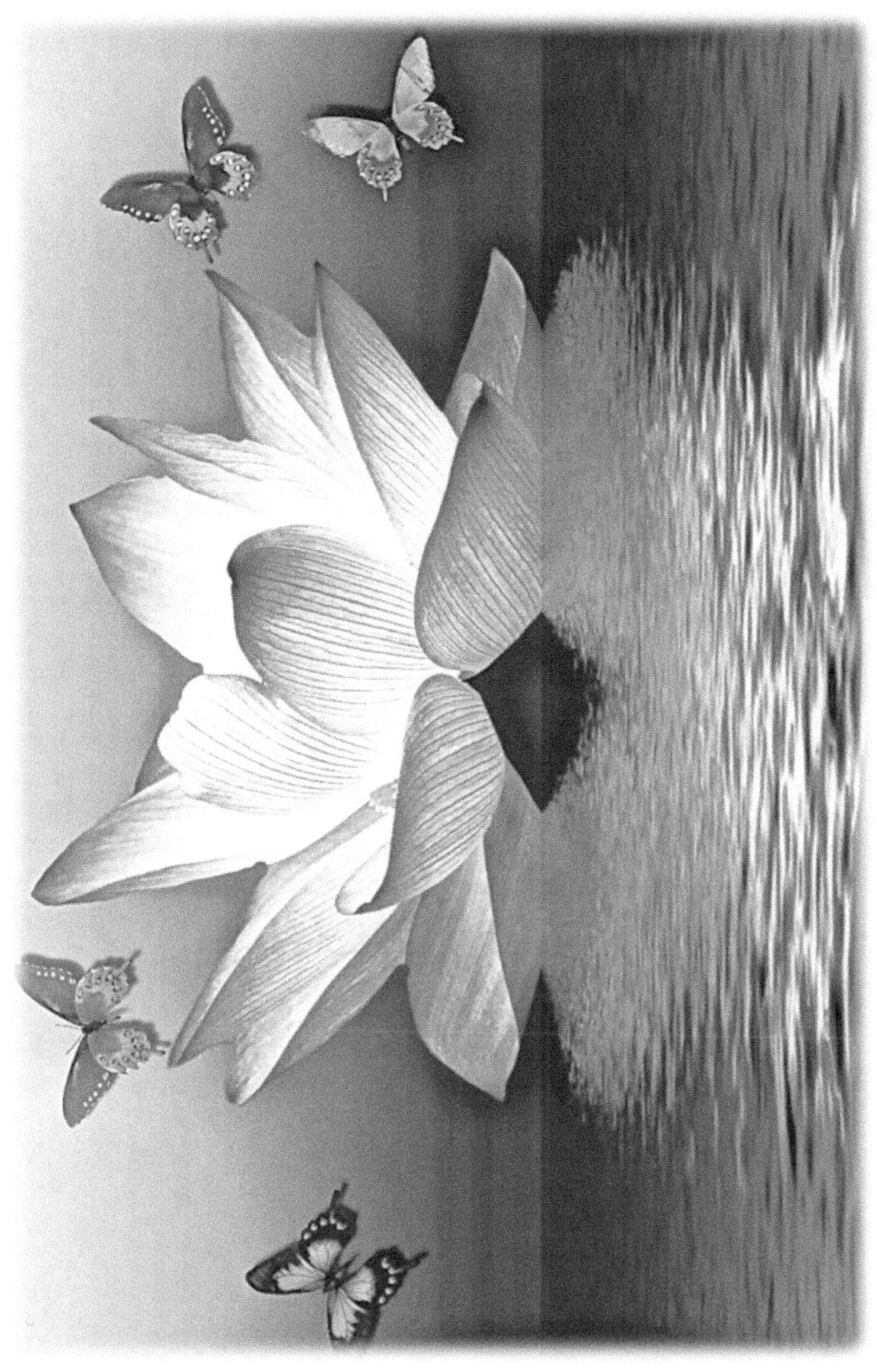

When we get tangled up with PROBLEMS, BE STILL so GOD can untangle the knots!

WHIMSICAL, NON GARDEN INCLUSION

The boldest DECISION you may make each day is to be in a GOOD mood

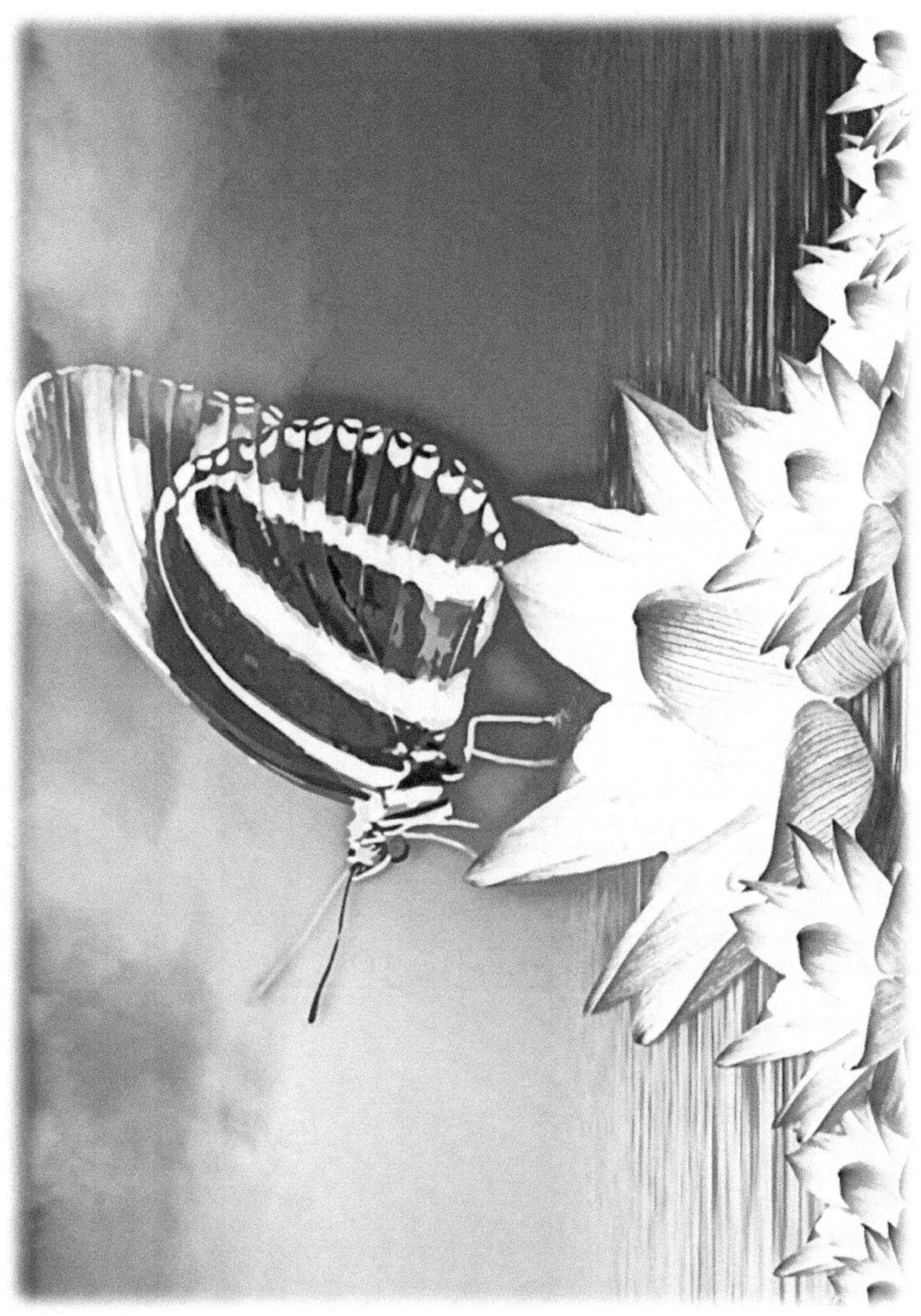

What every person desires is the UNFAILING *love of* GOD.

Proverbs 19:22

She speaks with WISDOM,
& FAITHFUL INSTRUCTION
is on her tongue.
Proverbs 31:26

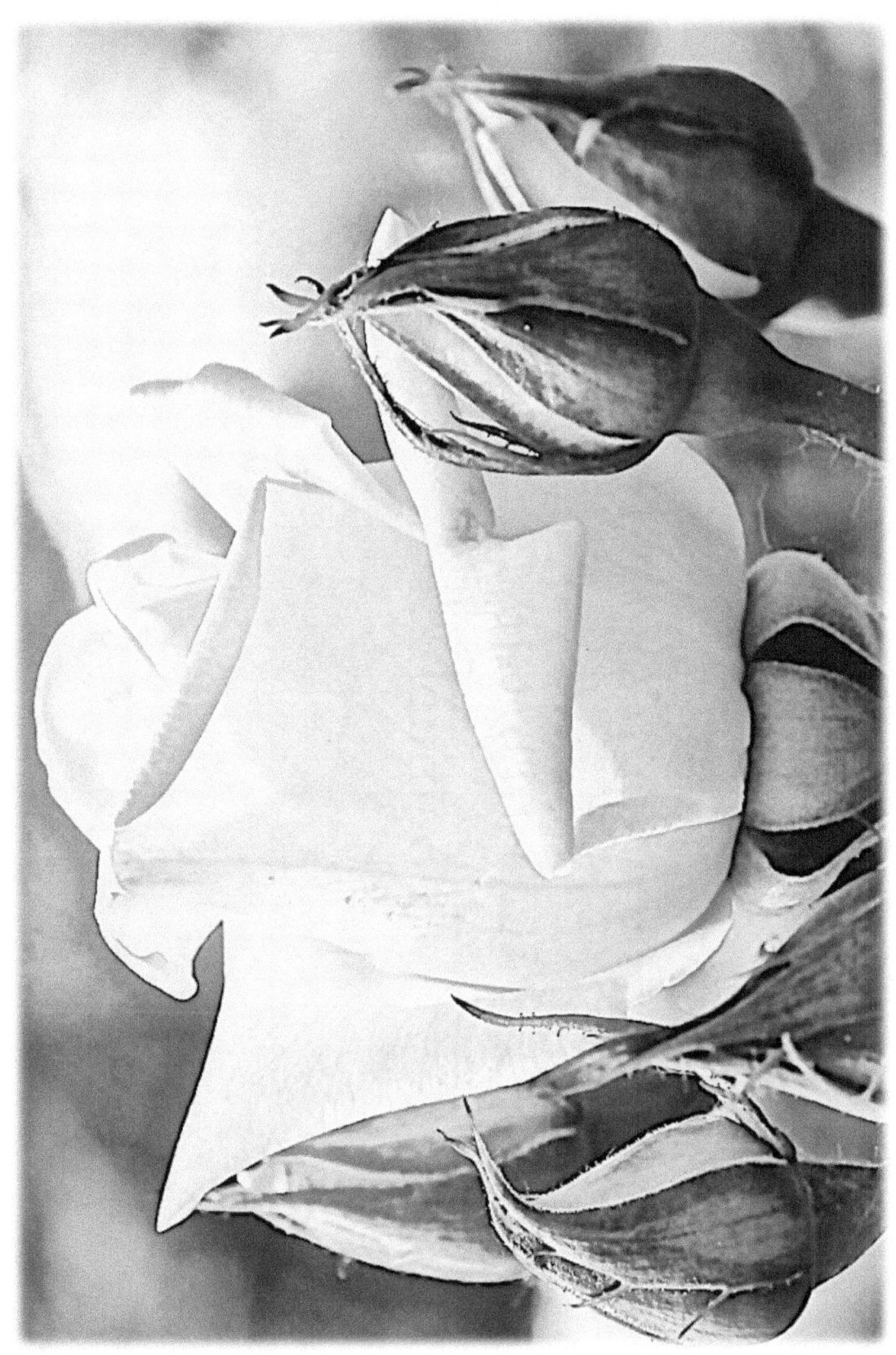

"My HEART rejoices in the LORD; in the LORD my life is lifted high."
1 Samuel 2:1

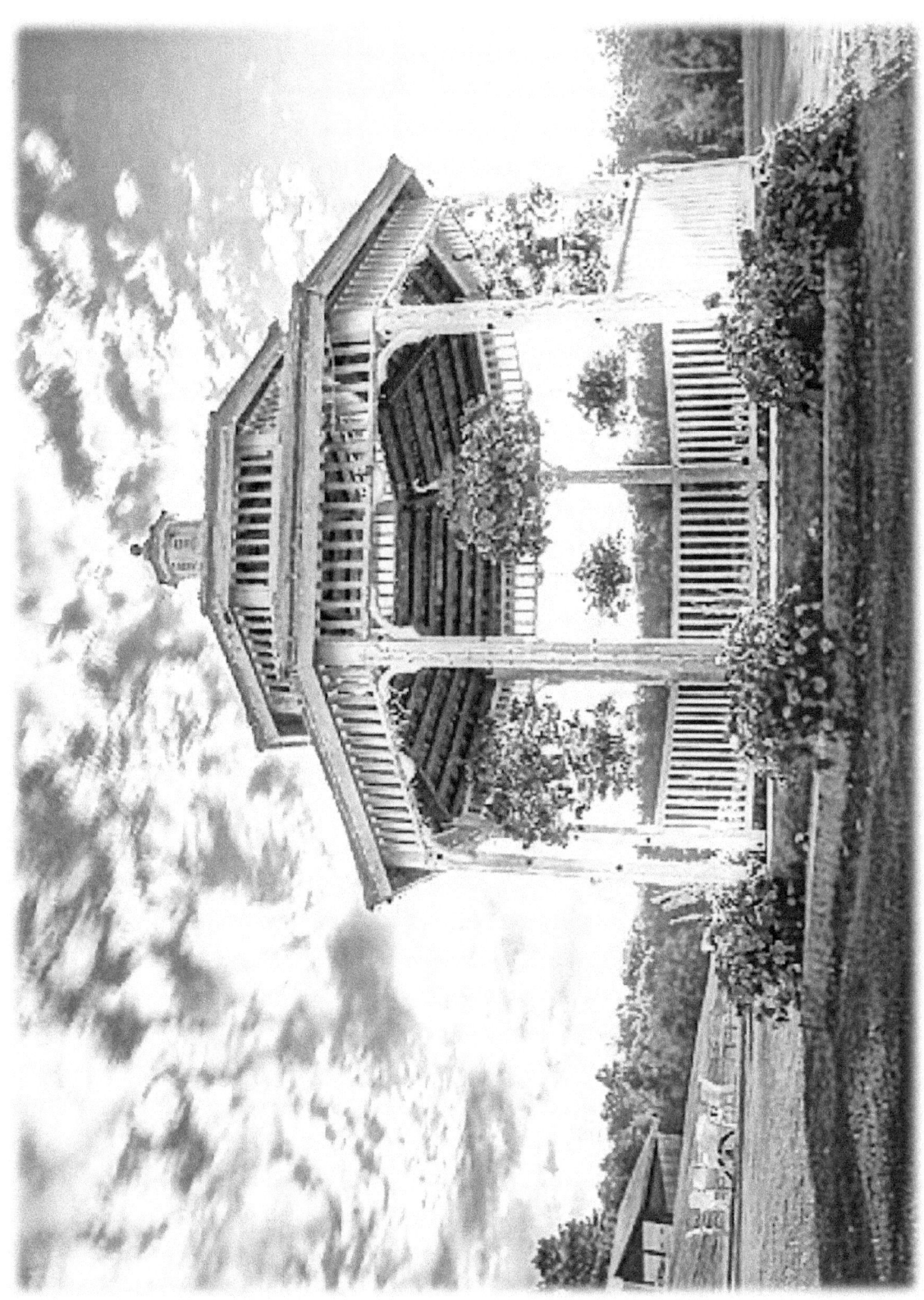

May Your unfailing LOVE be my comfort, according to Your PROMISE to me.

Psalm 119:76

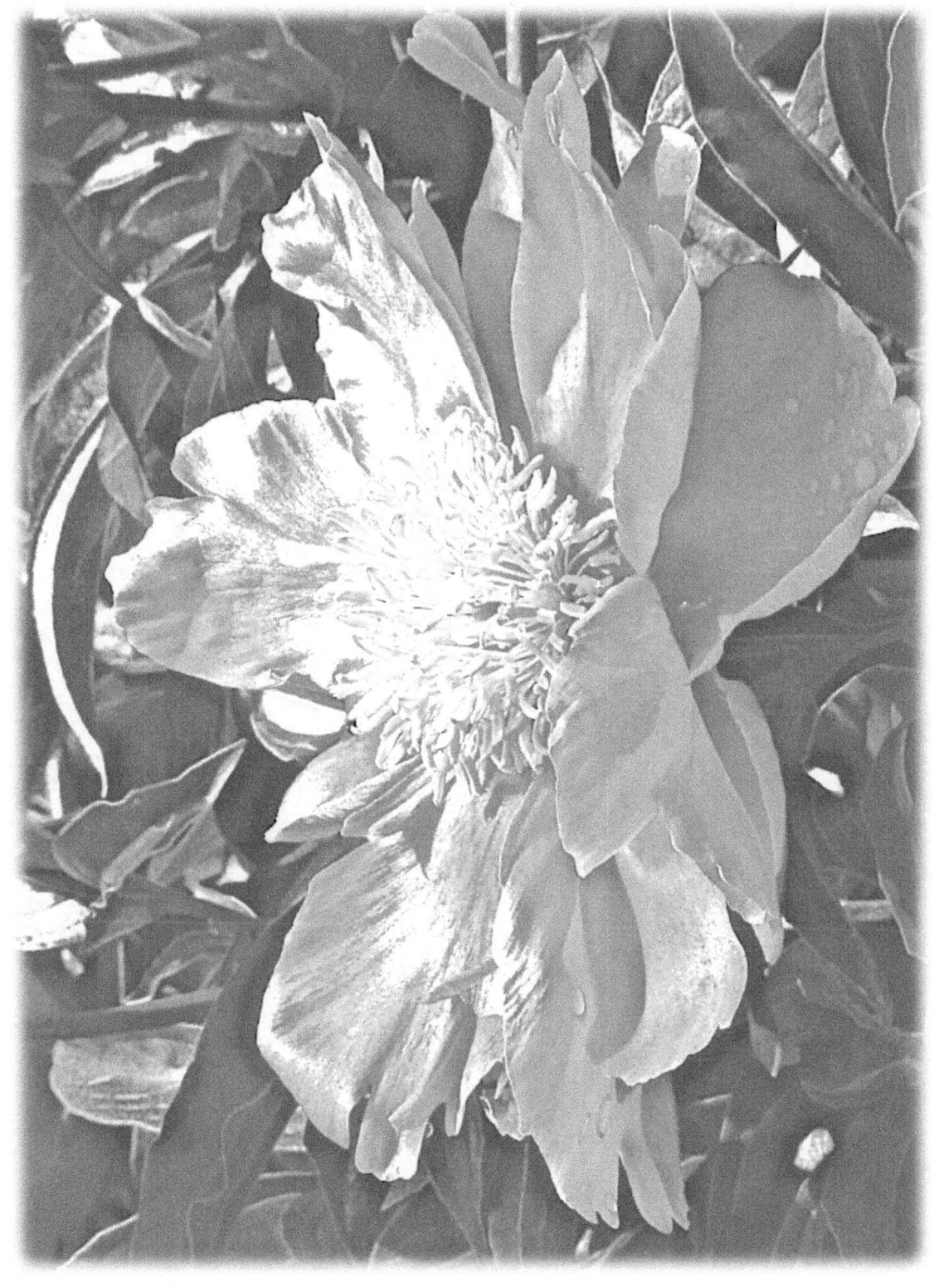

TREE PEONY

I have heard your PRAYER *& seen your* TEARS; *I will* HEAL *you.*

2 Kings 20:5

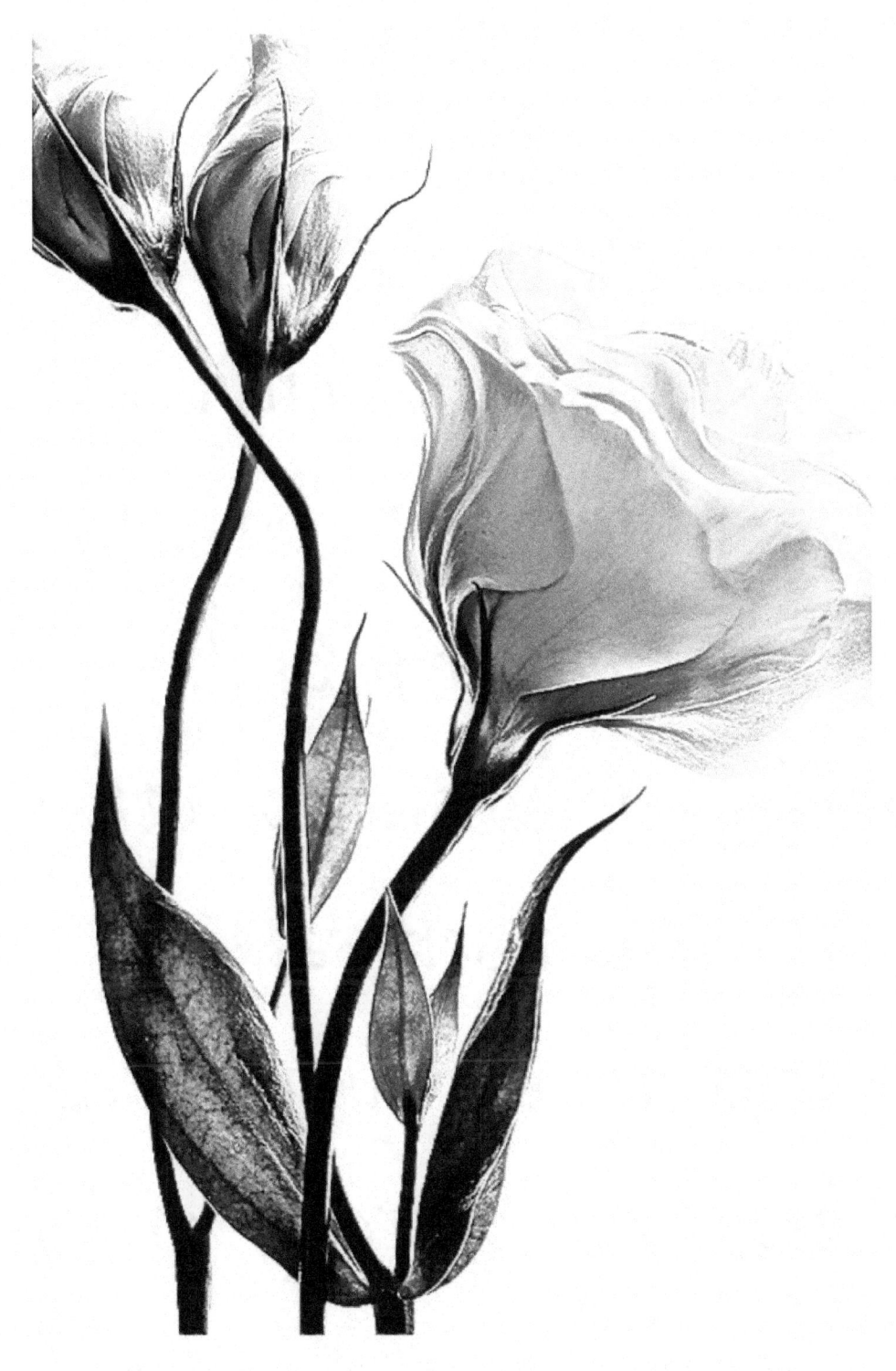

LOVE is PATIENT,
love is KIND.
It does not envy,
it does not boast,
it is not proud.
It does not dishonor others,
it is not self-seeking,
it is not easily angered,
it keeps no record of wrongs.

1 Corinthians 13:4-5 NIV

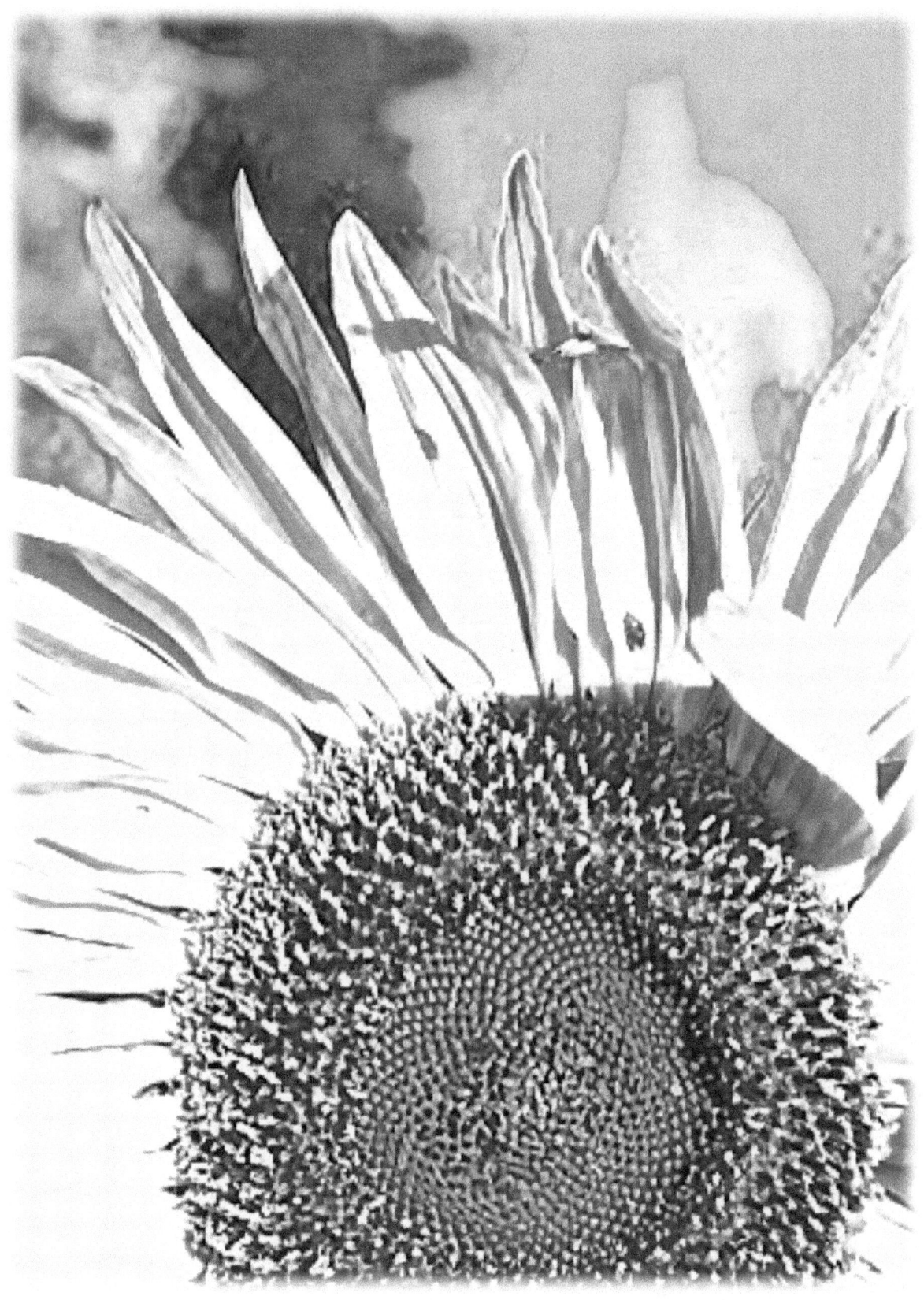

Consider it pure JOY, my brothers & sisters, whenever you face trials of many kinds, because you know that the testing of your FAITH produces PERSEVERANCE. Let perseverance finish its work so that you may be MATURE and complete, not lacking anything.

James 1:2-8

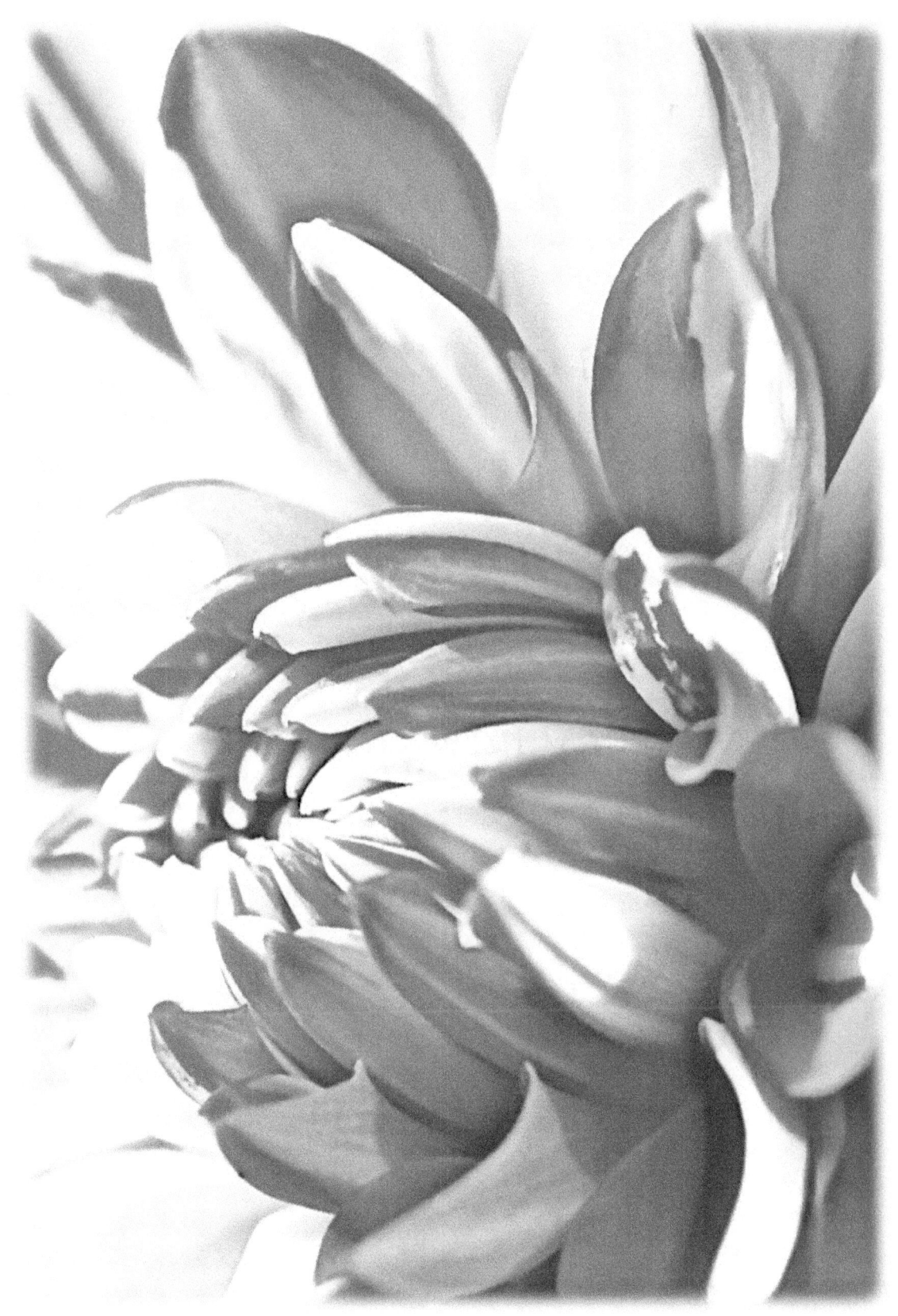

You are STRENGTHENED *with all* POWER *according to* HIS *glorious might so that you may have great* ENDURANCE *&* PATIENCE

Colossians 1:11

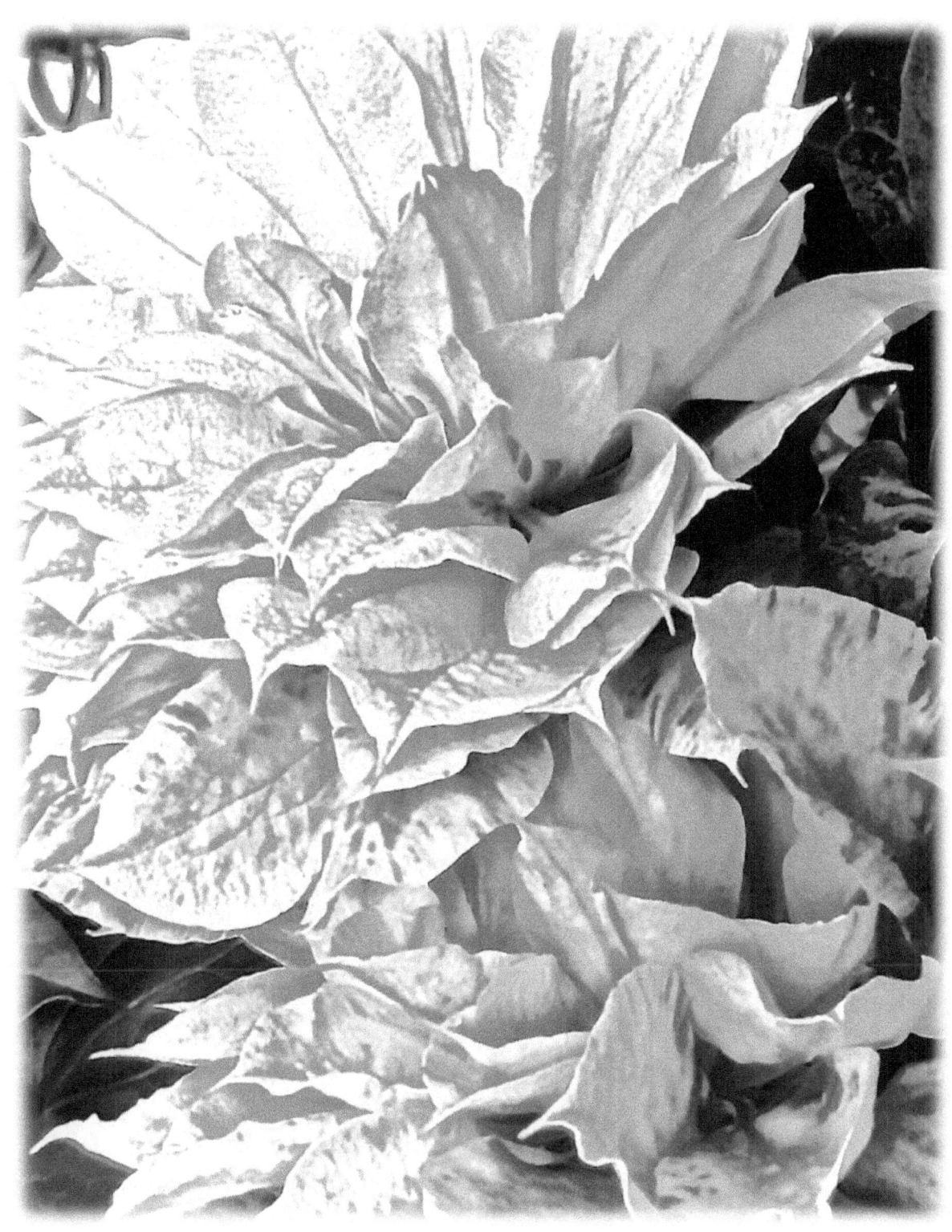

CLEMATIS

Return to the
LORD
your God,
for HE is gracious
& compassionate,
slow to anger
& abounding
in LOVE.
Joel 2:13

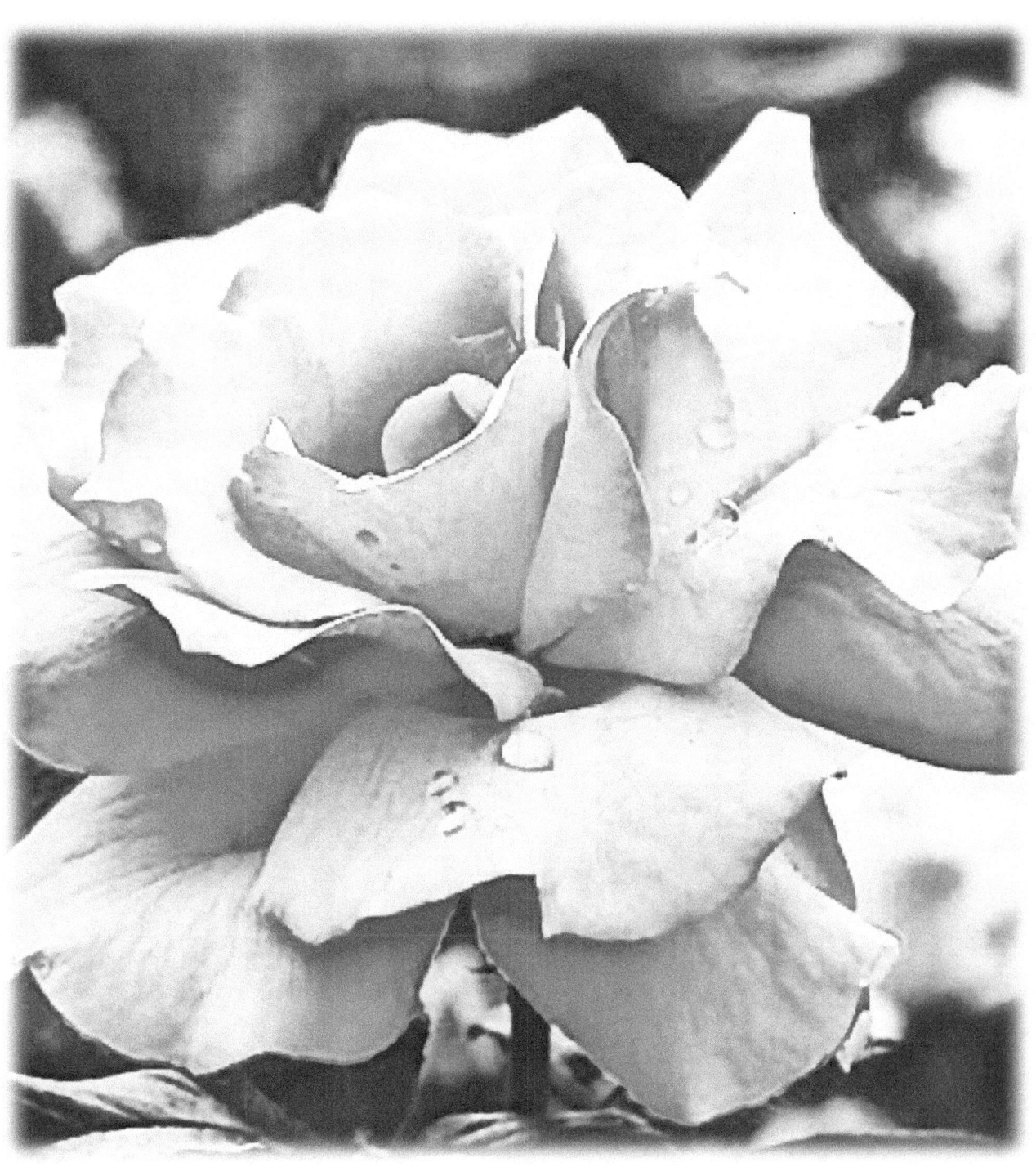

Through patience a ruler can be persuaded, and a gentle tongue can break a bone.

Proverbs 25:15

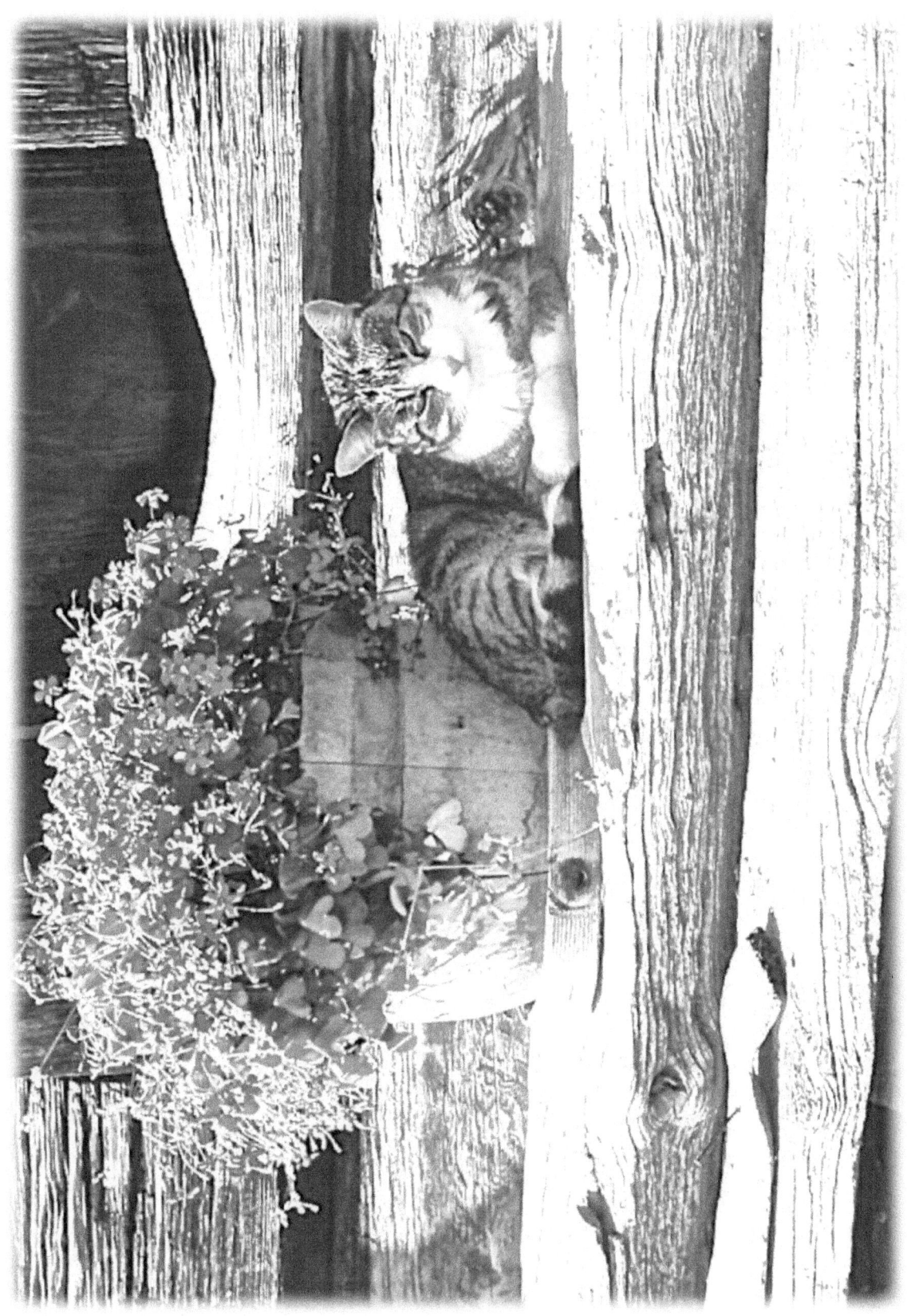

May the LORD now show you KINDNESS and FAITHFULNESS

2 Samuel 2:6

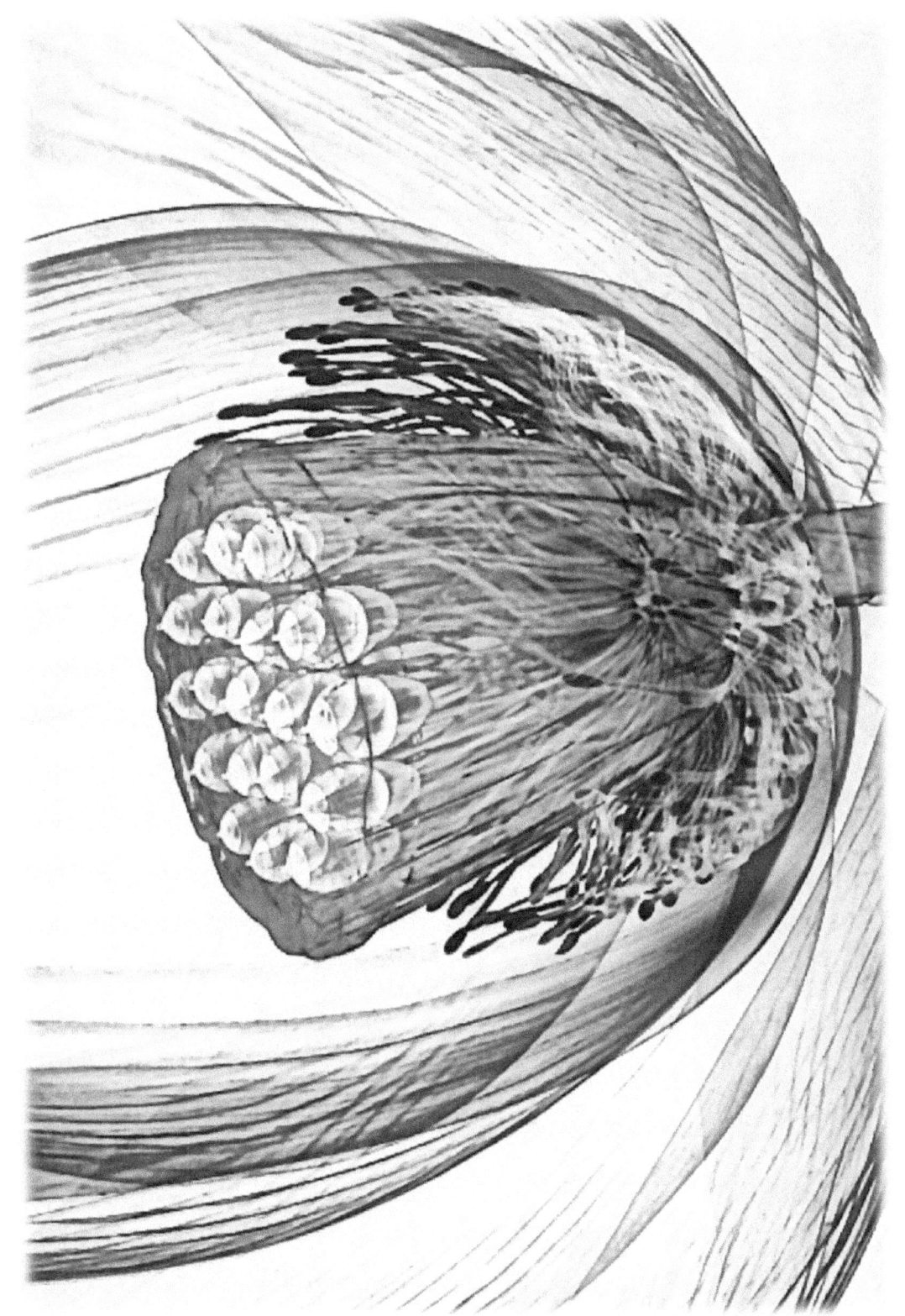

CHINESE LOTUS

Clothe yourselves with COMPASSION, kindness, HUMILITY, GENTLENESS & PATIENCE.

Colossians 3:12

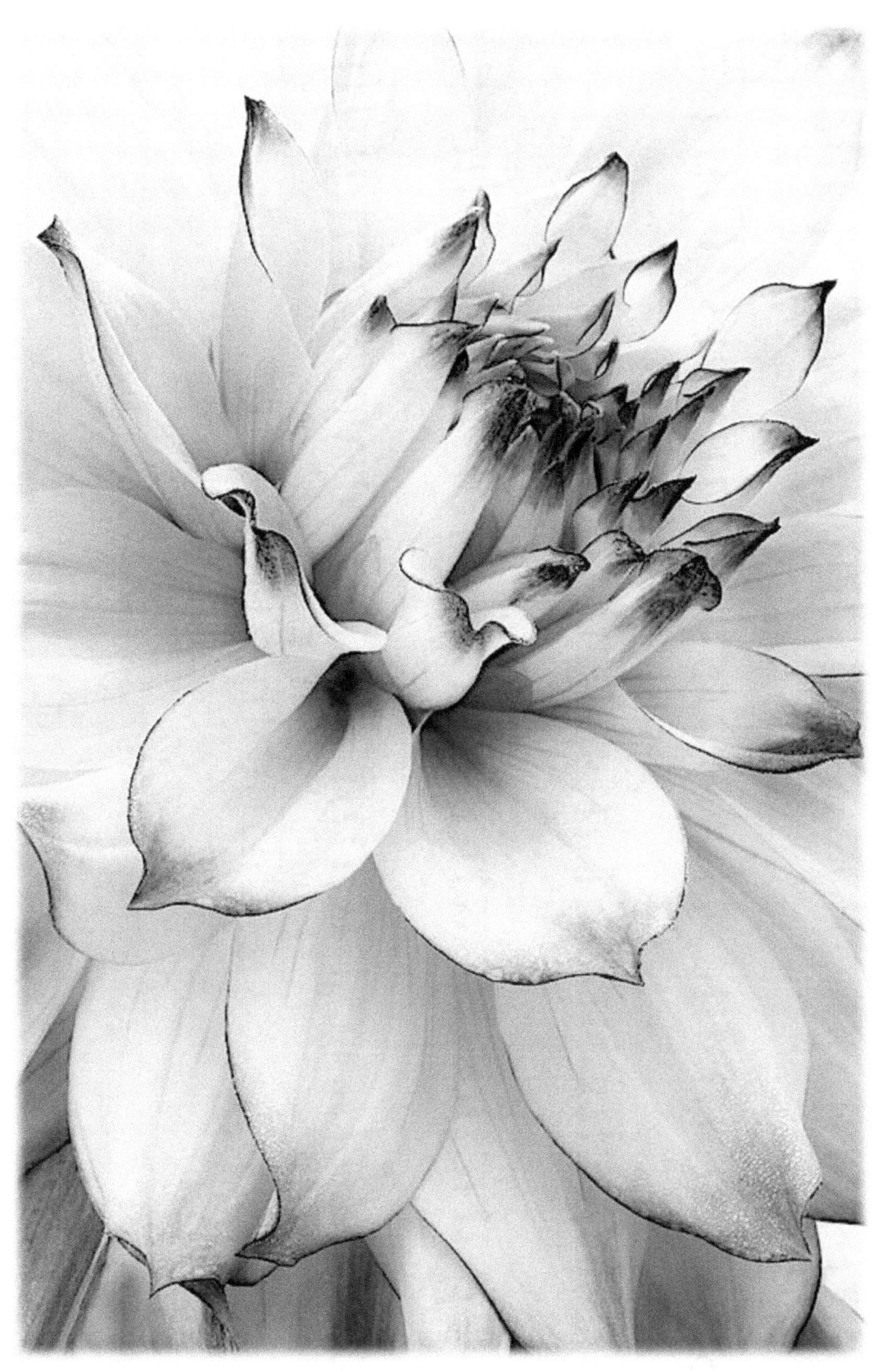

DAHLIA

But for that very reason I was shown mercy so that in me, the worst of sinners, Christ Jesus might display his immense patience as an example for those who would believe in him and receive eternal life.

1 Timothy 1:16

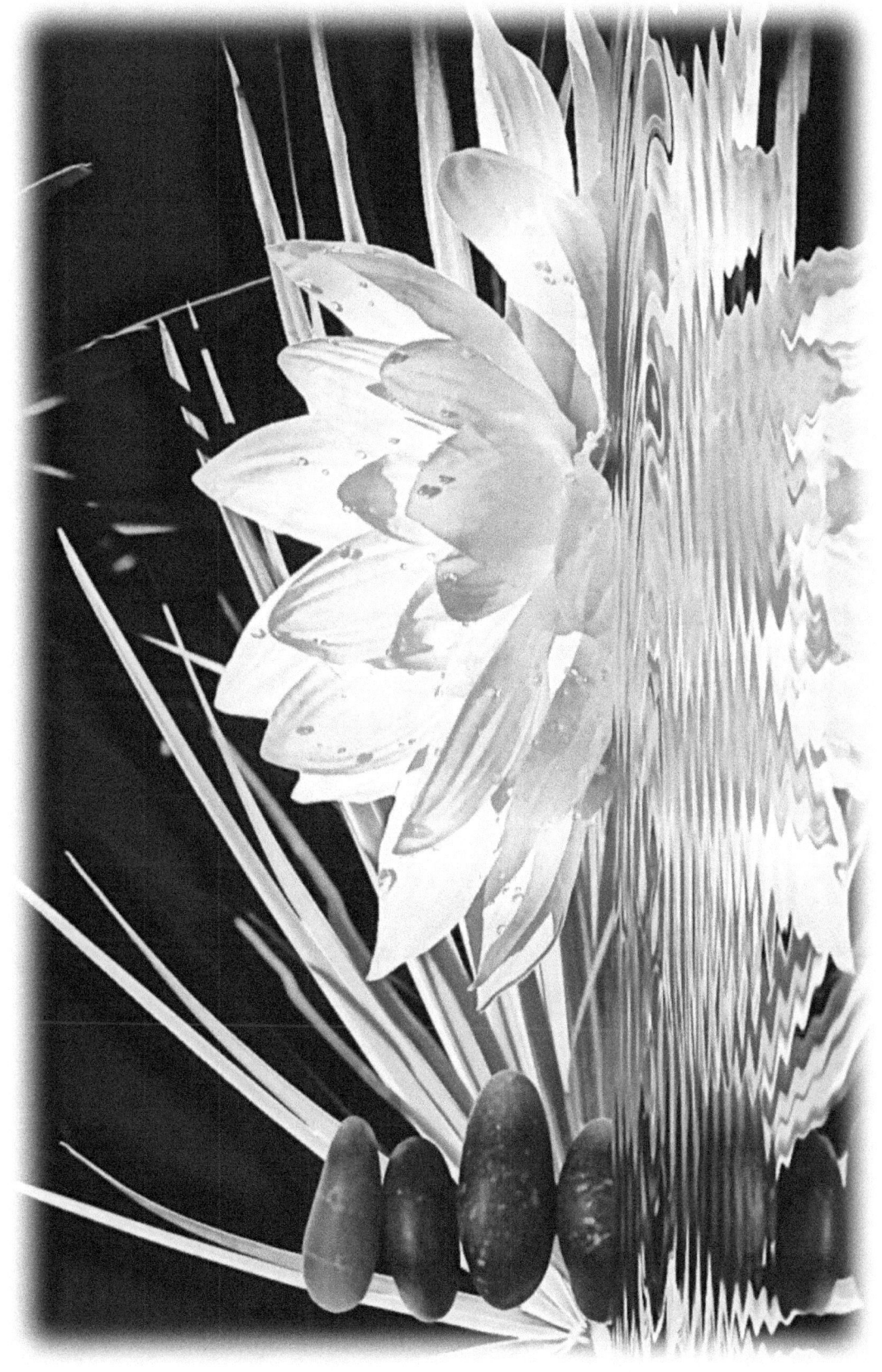

LOTUS BLOSSOM

Turn from evil and do GOOD.
seek PEACE and pursue it.

1 Peter 3:11

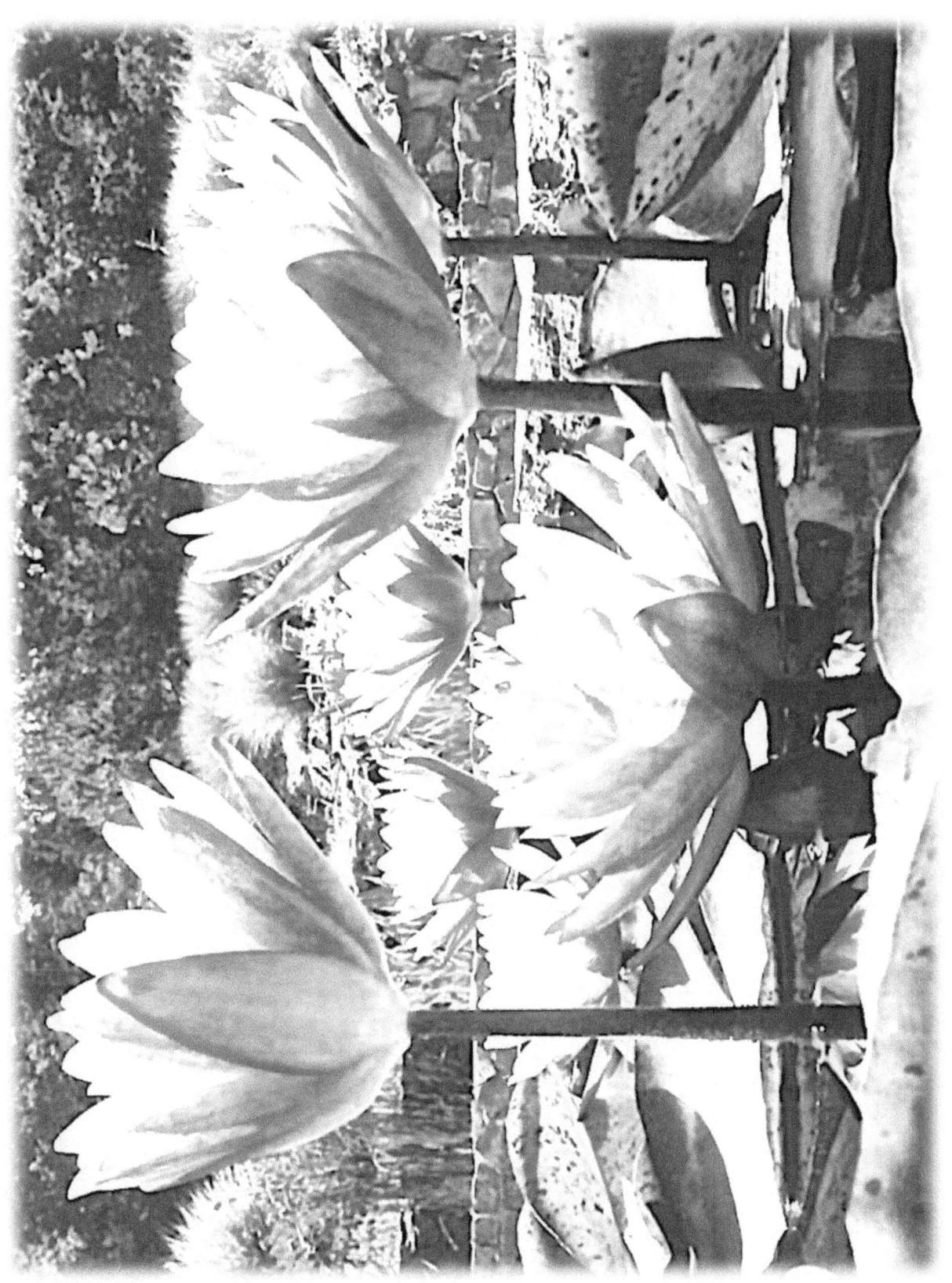

WATER LILY

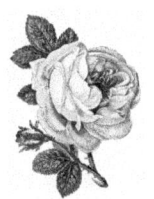 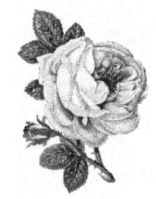 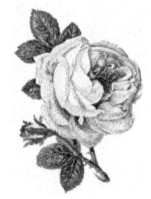

This page is for your notes & coloring tools tests

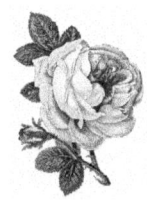 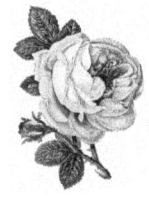 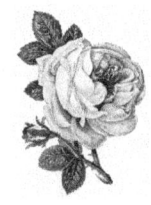

This page is for your notes & coloring tools tests

www.ingramcontent.com/pod-product-compliance
Lightning Source LLC
Chambersburg PA
CBHW080717190526
45169CB00006B/2407